GOLF
IN
DENVER

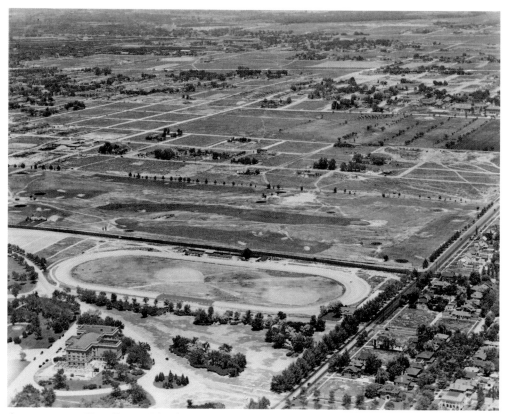

AERIAL VIEW, CITY PARK. This late-1920s aerial view of City Park, taken facing the northeast, shows several landmarks that are still familiar to Denverites today. Among these are the Denver Museum of Natural History (now the Denver Museum of Nature and Science), Ferril Lake, and the golf course at City Park. The horse racing track is also visible just north of the museum, but it no longer remains. (Denver Public Library, X-27185.)

FRONT COVER: During the early 20th century, many talented players were drawn to Colorado to take advantage of the favorable weather and rising popularity of the sport. John Rogers was one such figure. Shown here in the late 1920s or early 1930s, Rogers quickly became known as the "King of Swat" at the Denver Country Club. A World War I veteran, Rogers debuted in the U.S. Open in 1920, finishing 16th in that tournament seven years later. His passion, skill, and teaching exemplified qualities that many Colorado professional golfers were known for. (Colorado Golf Association.)

COVER BACKGROUND: Golfers tee off at City Park Golf Course in 1918. (Denver Public Library, F-44988.)

BACK COVER: In this late-1930s photograph, a lone golfer looks southwest toward the 18th green of Willis Case Golf Course and Berkeley Lake Park. In 1963, Interstate 70 was built north of Berkeley Lake, dividing the golf course from the park. (Denver Public Library, F-44986.)

GOLF
IN
DENVER

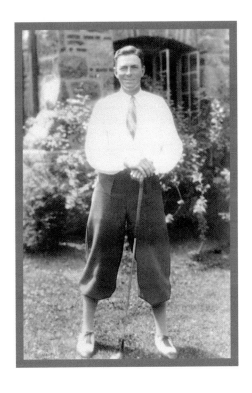

Rob Mohr and Leslie Mohr Krupa
Foreword by Edward Mate, Colorado Golf Association

ARCADIA
PUBLISHING

Published by Arcadia Publishing
Charleston, South Carolina

Printed in the United States of America

Library of Congress Control Number: 2010934818

For all general information, please contact Arcadia Publishing:
Telephone 843-853-2070
Fax 843-853-0044
E-mail sales@arcadiapublishing.com
For customer service and orders:
Toll-Free 1-888-313-2665

Visit us on the Internet at www.arcadiapublishing.com

For Bompa, whose love for history, good stories,
and the game inspired this book

CONTENTS

ACKNOWLEDGMENTS

First and foremost, we are grateful to Dan Hogan for sharing his stories and opening up his wonderful collection of golf photographs and memorabilia to us. Ed Mate, executive director of the Colorado Golf Association, deserves the highest praise and sincere thanks for his support, patience, and immense help. The Colorado Golf Association and the Colorado Women's Golf Association allowed us access to their records, photographs, and repeated use of their space.

Tom Woodard allowed us access to his private collection of photographs, guided topics in this book, and shared his and his contemporaries' experiences so we could accurately document the struggles of minorities to gain equality and respect on the course. We thank Coi Drummond-Gehrig at the Denver Public Library and Jennifer Vega at the Colorado Historical Society, both of whom were patient and great to work with. Thanks also go to Wendel Cox, Bruce Hanson, and Roger Dudley at Denver Public Library.

Joyce Mohr, Matt Krupa, Mark Barnhouse, and Jeff Mohr helped foster the idea for this book. We love you all. We also wish to thank Ed Cronin, Ted Patterson, Debbie and Mike Krupa, Jennie Harmon, Larry Epstein, Dr. Tom Noel, Geoff Moses, Kevin Dwyer, Loretta Lohman, Jerry Roberts, and Brent, Steve R., and Steve V. at Barringer High Country Marketing for their support.

Finally, the local golf organizations and individuals who accommodated our requests and helped gather these stories include: Cherry Hills Country Club; Columbine Country Club; Laura Cisco Quintana and Green Gables Country Club; Lakewood Country Club; Meghan McGinnes and Hiwan Homestead Museum; Jamie Melissa Wilms and Lakewood Heritage Center; Dr. Jeanne Abrams, director of Beck Archives at the University of Denver; Wendy Hall and the Carnegie Branch Library for Local History, Boulder, Colorado; Stuart Bendelow, John Gardner II, Scott Rethlake, and the City and County of Denver, which includes the following municipal courses: Wellshire, Willis Case, City Park, Overland, John F. Kennedy, Harvard Gulch, and Evergreen; Belmar Museum; Jefferson County Historical Society; Estes Park Museum; University of Colorado Athletic Department; and United States Golf Association.

Common courtesy abbreviations are Colorado Historical Society (CHS); Denver Public Library (DPL); Lakewood Country Club (LCC); Cherry Hills Country Club (CHCC); Green Gables Country Club (GGCC); Colorado Golf Association (CGA); Columbine Country Club (CCC); Jefferson County Historical Society (JCHS); *Denver Municipal Facts* (DMF); Carnegie Branch Library for Local History, Boulder, Colorado (CBLLHBC); City Park Golf Course (CPGC); United States Golf Association (USGA); and Colorado School of Mines (CUS-CSM).

FOREWORD

Francis Ouimet's historic victory over Harry Vardon and Ted Ray in the 1913 U.S. Open at The Country Club in Brookline, Massachusetts, introduced the Scottish game to an entirely new segment of American society. Prior to 1913, the game of golf in the United States was an aristocratic oddity. The 20-year-old Ouimet was far from aristocratic, and he and his 10-year-old caddie, Eddie Lowery, made a very unlikely team to dethrone the great Vardon and Ray. Ouimet's win, known as the "shot heard around the world," is perhaps the greatest Cinderella story in the history of sport and did more to advance the game of golf in the United States than anything before or since.

While Ouimet's victory was in far-off Boston, the cry of "fore" did reach west of the Mississippi and over the Rocky Mountains to the Mile High City of Denver. In 1913, there were four golf courses in the Denver area—Denver Country Club (1901), Lakewood Country Club (1908), Denver City Park (1912), and Interlachen (1902). From 1913 to 1930, the number of courses tripled, and it has been on a steady rise ever since.

Golf in Denver takes us on a 115-year journey that captures the incredible growth of golf, from Harry Vardon's first visit to Denver in 1900, through Arnold Palmer's historic win at Cherry Hills in 1960, up to the golf course construction boom of the 1990s and early 2000s.

Golf is a very visual game and it is very fitting that *Golf in Denver* is a very visual book. Nothing captures our game better than the proverbial thousand words provided by the photographs and pictures that make up this book. As a student of golf and history, I am grateful to Rob Mohr and Leslie Krupa for their efforts in bringing this book to life and capturing the history of our game. While golf has changed tremendously over the years, the basic fabric of the game remains unchanged. It is still a simple matter of getting that little white ball into the 4 ¼-inch hole and the (not so simple) matter of dealing with the challenges that arise along the way.

Here's to our great game, our great city, and to the mile-high marriage of *Golf in Denver*.

—Edward Mate
Executive Director, Colorado Golf Association

INTRODUCTION

Several years ago, as I entered the Overland Park Golf Course clubhouse in Denver, I passed by a glass case displaying several wood-shafted clubs, a few scorecards yellowed with age, and eight or nine vintage photographs. Pausing to look it over, I found that Overland Park claims to be the first golf course in Colorado, dating to 1896.

Knowing a little of Denver's history and pattern of population growth, this statement struck me as curious. Downtown Denver is 6 miles distant from Overland Park, and in 1896, the land between was mostly farms, ranches, and open land covered by sagebrush and native grasses. So why did anyone build a golf course there?

Also, with a hazy knowledge that golf came to the United States late in the 19th century and was a pastime practiced primarily along the Eastern Seaboard by the wealthy upper class, I wondered, how did it get started in Denver at such an early date?

Denver in the late 19th century was only 38 years old and carried a well-deserved reputation as a wild, woolly, somewhat lawless cow town. For the most part, prominent Denverites were self-made, independent Westerners somewhat suspicious of the prestigious business and social cultures on the east and west coasts.

So who were these people and why did they embrace a somewhat baffling Scottish game that most Denverites of the time would consider an effete, sissy waste of time?

The pursuit of answers to these questions led to a wider look at the history of golf in the Denver area. It has been a wonderful, circuitous journey through the 19th, 20th, and 21st centuries. Our hope is that this book will provide a snapshot of the rich history of the people, places, and events that make up golf in Denver.

—Rob Mohr

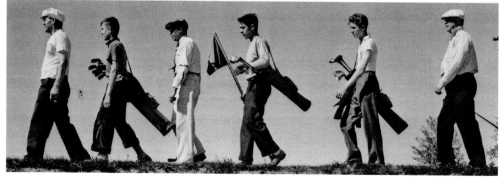

GOLFERS AND CADDIES, C. 1945. This photograph, taken by prolific and renowned photographer Harry Mellon Rhoads, shows golfers walking with their caddies on an unknown Denver golf course some time between 1940 and 1950. After World War II, golf became the "everyman's sport," and courses became a desirable place of employment for numerous young people enthusiastic about the game. (DPL.)

THE EARLY YEARS
1 8 8 5 – 1 9 1 9

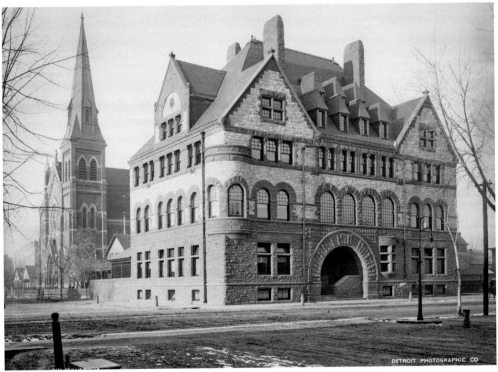

DENVER CLUB AT SEVENTEENTH STREET AND GLENARM PLACE. Founded in 1880, the Denver Club was the impetus for the Overland Park Club and, eventually, the Denver Country Club. Denver's wealthiest businessmen met in the statuesque clubhouse at Seventeenth Street and Glenarm Place, making lucrative deals with the hope of increasing Denver's national appeal as an investment capital. The Denver Club mansion was replaced with a high-rise in 1953, although the club continued to lease space in the new building. (CHS, J3680, Scan 20103680.)

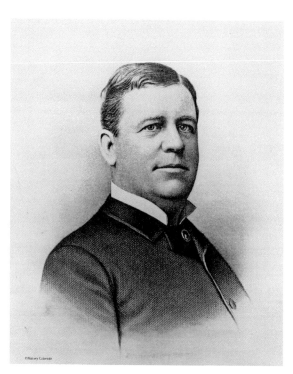

HENRY WOLCOTT PORTRAIT. Henry Wolcott came west in 1869, destination California, when his plan was derailed by a dental emergency. Broke, Wolcott landed in Blackhawk, Colorado, and found work with Nathanial P. Hill. Wolcott worked his way up in Hill's varied mining businesses and invested heavily in the mining industry. Wolcott was instrumental in starting up the Denver Club and developing Overland Park. By 1905, Wolcott had disengaged from his Colorado interests and had moved to New York. (CHS, F-12 139, Scan 10038325.)

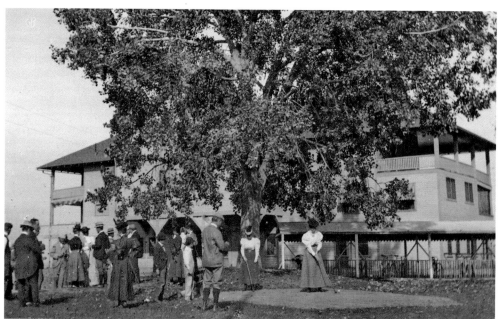

GOLFERS IN THE SANFORD CUP, 1897, OVERLAND PARK. The Overland Country Club clubhouse, shown here during the Sanford Cup in 1897, was built in 1889 and featured a bar running the full length of the building. Henry Wolcott laid out a nine-hole golf course in and around an oval racetrack in 1896. The clubhouse burned to the ground in 1903, after the departure of the Overland Country Club. (DPL, X-27650.)

THE EARLY YEARS: 1885–1919

FRANK WOODWARD AND WOMEN, 1898. In this 1898 photograph from Overland Country Club, Frank Woodward talks with a group of women as a boy identified as Earl Ellis looks on. Woodward dressed in the golf fashion made popular by Harry Vardon, the premier English professional of the time: plus fours (the bottom of the pants ended 4 inches below the knee) a long-sleeve shirt with vest, and a necktie. (DPL, X-19872.)

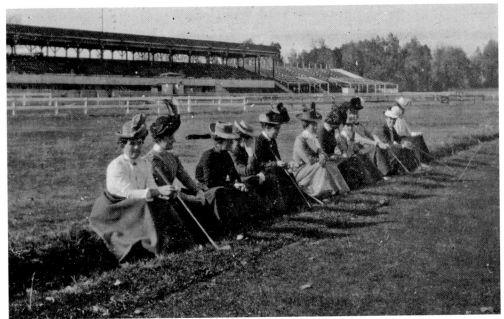

WOMEN CONTESTANTS AT THE SANFORD CUP, 1897. Contestants in the Sanford Cup pose on a ledge along a dry water canal at Overland Park in 1897. High scores in the first Sanford Cup tournament were attributable to women having just been introduced to the game, and also to the restrictive clothing of the time. Stylish women's clothing designed for physical activity would not appear until the late teen years of the 20th century. (DPL, X-19864.)

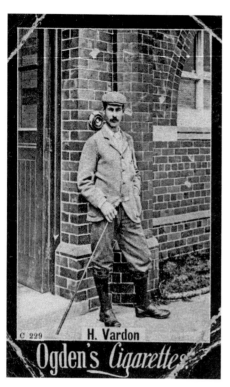

HARRY VARDON CIGARETTE CARD, C. 1903. Harry Vardon was the premier golf professional in the world from the 1890s to about 1920. He spent most of 1900 touring the United States, playing along the Eastern Seaboard from Maine to Florida with excursions into Pennsylvania, Ohio, Illinois, Michigan, and Colorado. Vardon was paid $250 per exhibition. Cigarette cards with famous sports figures were popular promotional items in the early 20th century. (Rob Mohr.)

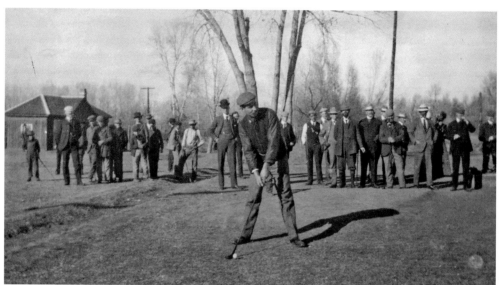

HARRY VARDON AT OVERLAND, 1900. Harry Vardon tees off on the second hole during his exhibition match at Overland Park on December 8, 1900. Frank Woodward and Walter Fairbanks of the Overland club made several overtures to Vardon to schedule an exhibition at Overland Park. When Fairbanks lined up a second Colorado exhibition at the Town And Gown Golf Club in Colorado Springs, Vardon agreed to come, assured of earning $500 to make the 4,000-mile round-trip train journey. (DPL, X-19893.)

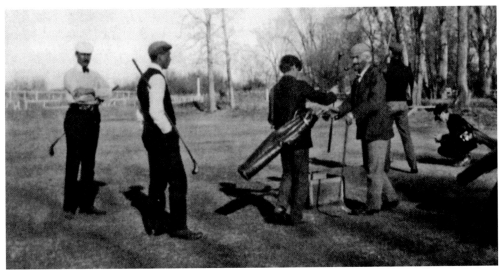

FOURSOME TEES OFF, 1900. This foursome with caddies prepares to tee off during the December 8, 1900, exhibition match at Overland. Frank Woodward, in the white shirt, looks on as Walter Fairbanks accepts a club from his caddy. John Russel, the Overland Club professional, ponders his next shot. Harry Vardon (with his back to the camera) played his ball against the other three players' best ball and won the 36-hole match three and two, shooting 72-74, five strokes better than the best ball of his opponents. (DPL, X-19894.)

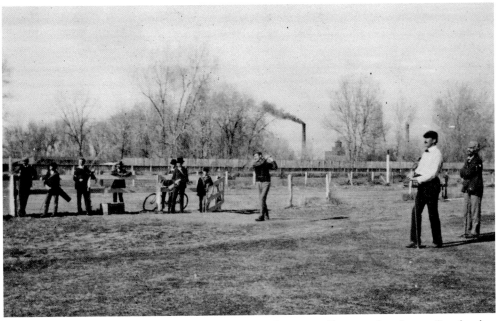

HARRY VARDON AT OVERLAND, 1900. Harry Vardon tees off on number five at Overland as Frank Woodward, in the white shirt, and Walter Fairbanks, on the far right, watch the ball's flight. The horse racing paddock is visible beyond the rail of the track, and the smoke stack in the background is the Overland Cotton Mill. (DPL, X-19908.)

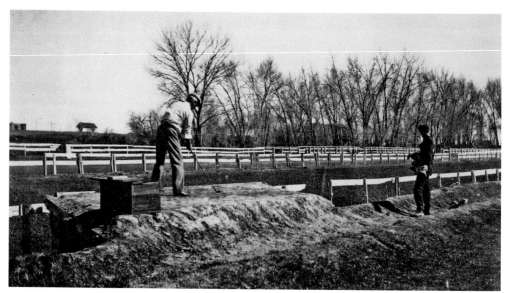

OVERLAND HOLE, FOURTH HOLE TEE BOX. Walter Fairbanks hits his tee shot on the fourth hole at Overland on December 7, 1900. Willard Ward related a story about Joseph Choate's play at this hole around 1897: "Choate gave a mighty swipe; the ball struck the very top of the fence and bounded back directly over his head. When he saw it coming, he hauled off again and swatted it with his driver clean over the fence and at least 150 yards out into the ground surrounded by track." (DPL, X-19881.)

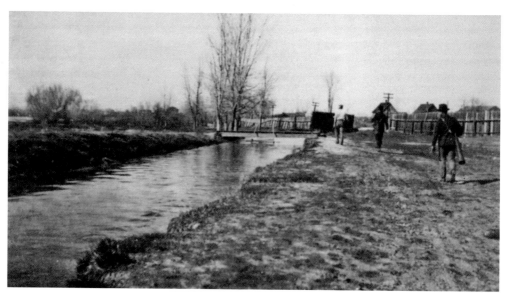

GOING TO WATERLOO. Walter Fairbanks and two caddies walk along the Waterloo ditch at Overland Country Club in December 1900. Water availability was, and still is, the critical component of building a golf course. Overland Country Club pulled water from the nearby South Platte River and channeled it through a series of ditches descending in size. Holes were punched in the sides of the ditches, allowing the water to flow out and flood the course. (DPL, X-19882.)

THE EARLY YEARS: 1885–1919

FALL IN DENVER POSTCARD, 1905. This postcard highlights Overland Country Club as one of the attractions Denver had to offer in the early 20th century. Of the estimated 300 Overland Country Club members, over 200 left to form the new Denver Country Club in 1903. The remaining golfers continued to play under the Overland Country Club name until 1908, when they formed the Colorado Golf Club and moved to their new home in Lakewood. (Rob Mohr.)

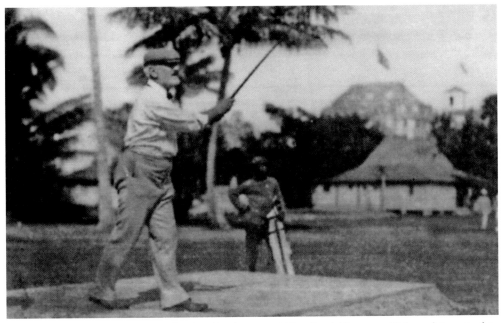

WALTER FAIRBANKS, 1910. Walter Fairbanks joined Overland Country Club on his arrival in Denver from England in 1898. Fairbanks was described as an investor, and in the 1900 census he listed his occupation as "capitalist." He spent most of his time on the golf course, playing in Colorado in summer and playing a circuit of high-level amateur events in Florida and Southern California in the winter. Fairbanks is shown in Florida in 1910. (*American Golfer*, May 1910.)

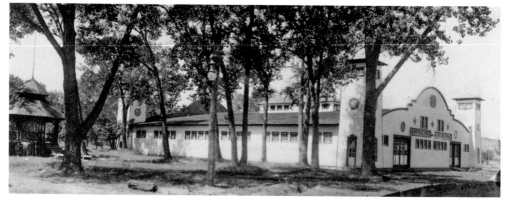

HORTICULTURE AND AGRICULTURE BUILDING, 1908. In 1908, the grounds at Overland Park played host to the Colorado Inter-State Fair and Exposition. This exposition building was one of several large buildings constructed on the grounds for the event. The golf course at Overland was abandoned when remaining Overland Country Club golfers left to start the Colorado Golf Club in Lakewood in the spring of 1908. Golf wasn't played again at Overland Park until 1932, when Denver opened a nine-hole municipal course on the site. (DPL, X-27699.)

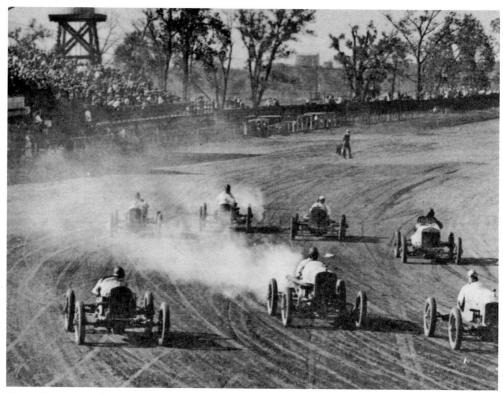

AUTO RACES AT OVERLAND, C. 1917. Overland Park racetrack was used for horse racing during Overland Country Club's tenure at the park. After Overland Country Club morphed into Denver Country Club and abandoned the premises in 1903, approximately 100 golfers remained, continuing to use the course. The racetrack became host to motorcycle and automobile racing. (DPL, Z-2.)

FRANK WOODWARD PORTRAIT.
Frank Woodward, a charter member
of Overland Country Club, served as
president of Denver Country Club, the
Trans-Mississippi Golf Association,
the Western Golf Association, and the
United States Golf Association. He was
described as an "orator, wit, dispenser of
epigrams, and winner of championship
tournaments by the grace of his post
prandial pleading." His persuasive skills
were successful in bringing the 1910
Trans-Mississippi Amateur and the 1912
Western Golf Association Amateur to
Denver Country Club. (DPL, H-109.)

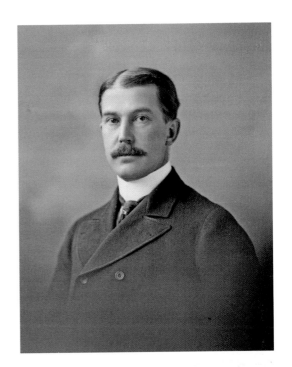

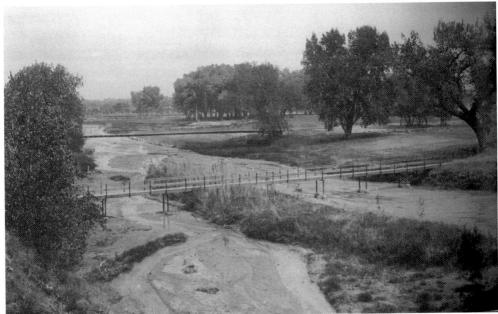

VIEW FROM FIRST AVENUE AND DOWNING STREET, 1905. In 1901, spurred by internal differences
over the lease at Overland Park, the Overland Park Club reorganized as the Denver Country
Club. All members of Overland Park in good standing were eligible to join. A committee quickly
purchased land originally belonging to entrepreneur John J. Riethmann along Cherry Creek. The
land, shown here from Downing Street and First Avenue in 1905, was mostly barren, save for the
Cottonwood trees and bushes that lined Cherry Creek. (DPL, X-22072.)

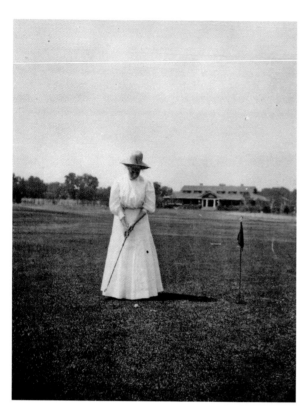

WOMAN PUTTING AT DENVER COUNTRY CLUB, C. 1910. Although women did struggle through much of the 20th century to gain equality and respect on the course, it is surprising how many women took to the game from its earliest days in Denver. Here, an unidentified woman putts at the Denver Country Club around 1910. The original clubhouse, completed in 1906, is visible in the distance. (Leslie Krupa.)

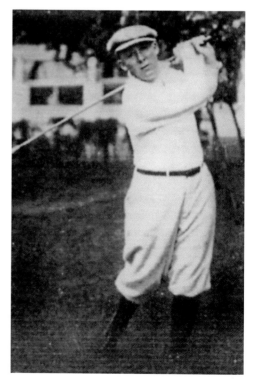

HARRY LEGG, 1910 TRANS-MISSISSIPPI AMATEUR CHAMPION. Harry Legg won the 1910 Trans-Mississippi Amateur Championship, held at Denver Country Club. Legg dominated the Trans-Miss Amateur for four years, winning in 1909, 1910, 1911, 1912, and repeating again in 1916. The Trans-Mississippi Golf Association was established in 1901 as an organization of golf clubs located west of the Mississippi River. The 1910 championship was Denver Country Club's first foray into hosting a tournament of significant stature. (*American Golfer*, August 1912.)

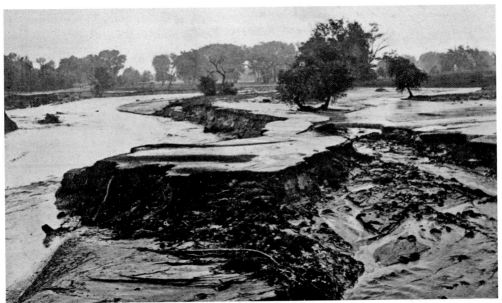

1912 FLOOD AT THE DENVER COUNTRY CLUB. On the afternoon of Sunday, July 14, 1912, a torrential rainstorm turned Cherry Creek into a raging current that destroyed two greens and left a swamp of mud and sand over half of the Denver Country Club. Frank Woodward rallied the club members and maintenance staff to work around the clock to get nine holes open for the Western Amateur Championship. This postcard shows the aftermath of the flood on Sunday afternoon before start of play on Monday. (Rob Mohr.)

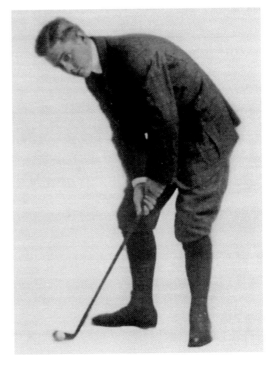

CHICK EVANS, 1912 WESTERN GOLF ASSOCIATION CHAMPION. Charles "Chick" Evans was the premier amateur of the 1910s and early 1920s. Evans won the 1912 Western Amateur at the Denver Country Club in an exciting finish one up over Warren Wood by halving the final hole. Evans won the Western Amateur nine times, the U.S. Amateur twice, and the U.S. Open once. (*American Golfer*, August 1912.)

LAWRENCE BROMFIELD. Dr. Lawrence Bromfield was 21 when he won the first of his eight Colorado Match Play Championships by defeating M. A. "Mac" McLaughlin of Lakewood Country Club at the Denver Country Club in August 1912. Bromfield won seven Denver City Championships and was club champion at Denver Country Club 10 times. Bromfield was a member of the DCC club team from age 17 in 1908 until his death at age 76 in 1967. (*American Golfer*, November 1912.)

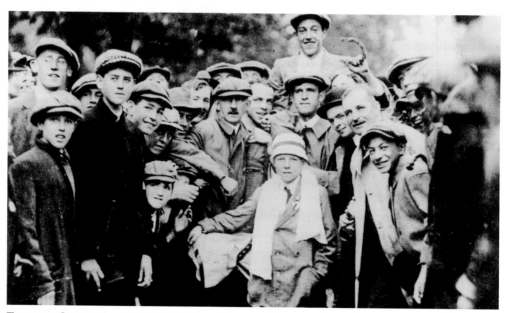

FRANCIS OUIMET AT 1913 U.S. OPEN. Francis Ouimet is hoisted onto the shoulders of the crowd after his victory in the famous 1913 U.S. Open. Ouimet, who also won the 1914 Amateur Championship, was stripped of his amateur status in 1916 by the USGA, under the leadership of Frank Woodward, citing his ownership of a sporting goods store as the reason. Woodward became a lightning rod for the firestorm of criticism that followed. In 1919, the USGA restored amateur status to Ouimet. (USGA.)

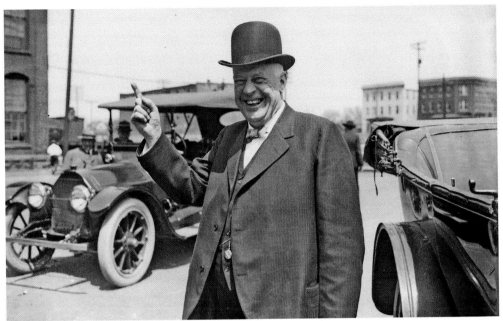

MAYOR ROBERT SPEER, C. 1914. Denver mayor Robert Speer was a proponent of the City Beautiful Movement, which promoted the virtues of parks, tree-lined boulevards, landscaped civic buildings, and public spaces. During his administration from 1904 to 1912, the City of Denver got involved with public golf by an association with the Interlachen Golf Club and by making two land deals to create the parcel of land that would become City Park Golf Course in 1912. (DPL, RH-862.)

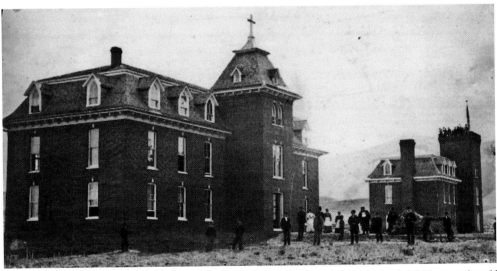

JARVIS HALL, LATE 1890S. Early in the 20th century, a group of men started dabbling with golf on the grounds of Jarvis Hall at the Colorado School of Mines campus in Golden, Colorado. By 1902, they took control of the property that would become Inspiration Point, west of Sheridan Boulevard near Fiftieth Avenue. They laid out a rudimentary nine-hole course and named it Interlachen Golf Club. (CHS.)

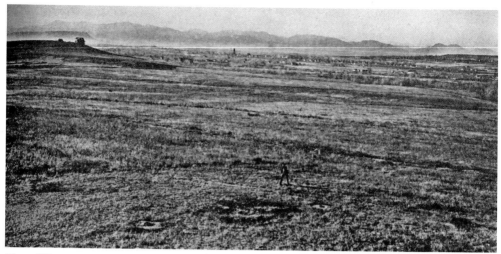

VIEW WEST FROM INTERLACHEN GOLF COURSE, C. 1911. The wild, rudimentary nature of the Interlachen Golf Course is apparent in this photograph from 1911 or 1912. A lone golfer can be seen just below center right. It was probably as hard for him to differentiate the rough from the fairway as it is in this photograph. The Clear Creek Valley beyond the course stretches west to Golden. (DMF, December 1912.)

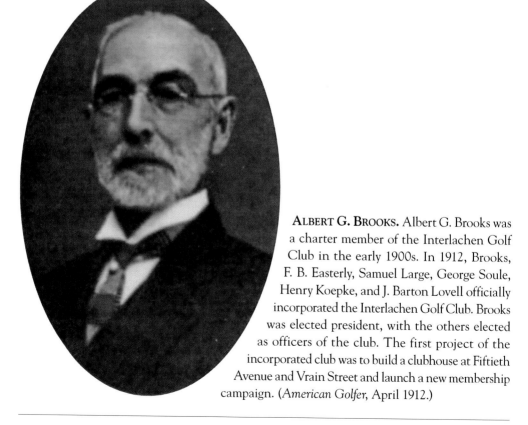

ALBERT G. BROOKS. Albert G. Brooks was a charter member of the Interlachen Golf Club in the early 1900s. In 1912, Brooks, F. B. Easterly, Samuel Large, George Soule, Henry Koepke, and J. Barton Lovell officially incorporated the Interlachen Golf Club. Brooks was elected president, with the others elected as officers of the club. The first project of the incorporated club was to build a clubhouse at Fiftieth Avenue and Vrain Street and launch a new membership campaign. (*American Golfer*, April 1912.)

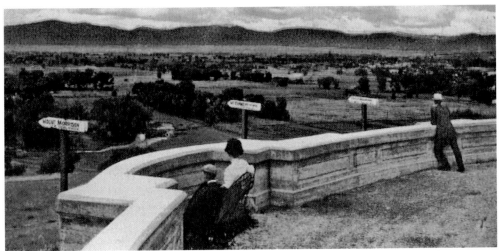

INSPIRATION POINT, 1908. In 1906, the Denver Parks Commission built Berkeley Park on the land around Berkeley Lake in North Denver. In 1908, Denver purchased the top of the ridge west of Berkeley Park and built a wide boulevard. They planted grass and trees and named the new city park Inspiration Point. Interlachen Golf Club, having lost the two golf holes on top of the point, reconfigured their course around the base of the ridge. (Rob Mohr.)

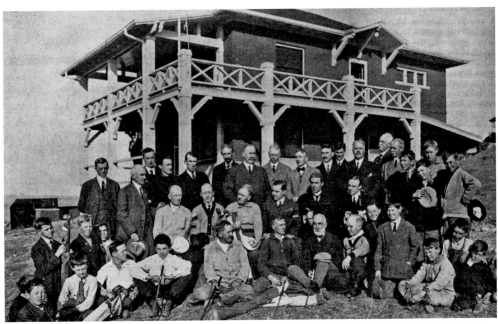

INTERLACHEN GOLF CLUB CLUBHOUSE, 1912. Denver entered an agreement with the Interlachen Golf Club to build a nine-hole course north of Berkeley Park above Fiftieth Avenue in 1909. Denver and Interlachen would co-maintain the course and share access. In 1912, Interlachen built a two-story redbrick clubhouse at Fiftieth Avenue and Vrain Street, approximately where the El Jebel Shrine Mosque is located today. This photograph shows the new clubhouse, members, and caddies. (DMF, December 1912.)

LORD DUNRAVEN. By the late 1860s, word of mouth had spread internationally that Estes Park was a paradise for outdoor activities. The man shown here, Windham Thomas Wyndham-Quin, Lord Dunraven, was drawn to the West like many sportsmen. Enamored of Estes Park, Lord Dunraven bought the entire Estes Valley in 1874, with heavy criticism that he used unscrupulous means to do so. One of the activities that guests could enjoy on his new estate was golf. The links, built in 1875, was widely considered to be the first golf course in Colorado. (Estes Park Museum.)

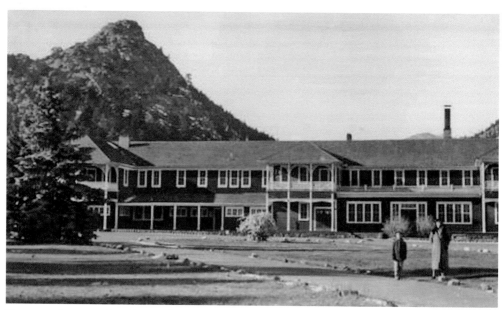

ELKHORN LODGE, 1901. Located at 8,000 feet above sea level, Estes Park was an unlikely breeding ground for golf by the early 20th century. Yet the beauty and remoteness of Estes Park attracted outdoor types who preferred natural, rugged links. The Elkhorn Lodge, built in 1877, provided an ideal location for Estes Park's second golf course, which due to the altitude was made entirely of sand and used tin cans in place of cups. (DPL, X-8286.)

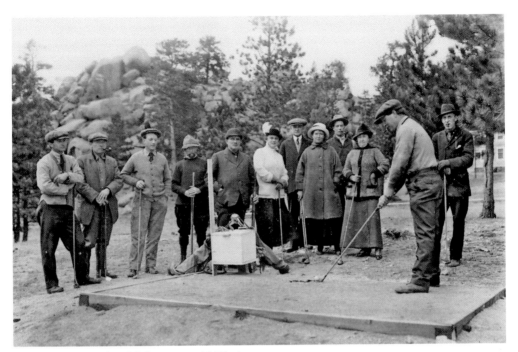

FREELAN OSCAR (F. O.) STANLEY, 1905. American businessman F. O. Stanley (at right) opened his majestic Stanley Hotel overlooking Estes Park in 1909. Stanley had made his fortune from the Stanley Steamer and catered all aspects of his hotel to the upper class. Elegance called for a golf course, so nine holes were built near the hotel for guests in the 1920s. Shown above is the first tee in the early 1920s. Once the Stanley Hotel golf course was built, Estes Park was saturated with choices for golf lovers. More importantly, the popularity of golf there prematurely illustrated the shifting social dynamics that would change the face of golf in the 20th century. In cities at the time, golf was immensely popular, but only among wealthy urbanites. Although the Stanley Hotel fit this mold, the old course on Lord Dunraven's estate and the links at the Elkhorn Lodge primarily catered to outdoorsmen and original settlers of the valley respectively. (Above, courtesy of Estes Park Museum; right, courtesy of CHS, X475, Scan 20010475.)

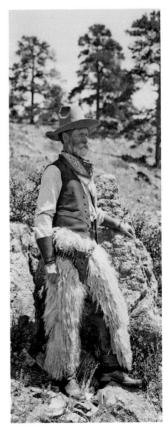

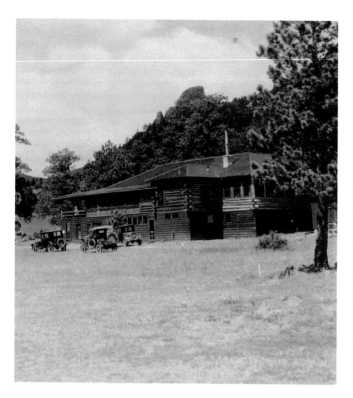

ESTES PARK GOLF CLUB CLUBHOUSE, C. 1918. After losing interest in Estes Park, Lord Dunraven sold his estate, including his golf course, to the Estes Park Improvement Company in 1907. The course became known as the Estes Park Golf and Country Club, and a clubhouse was constructed in 1909 in the same style as Lord Dunraven's original cottage. Little is known about the early years of the course, before operators redesigned and laid out 18 holes in 1917. (Estes Park *Trail Examiner.*)

LAKEWOOD COURSE MAP, 1910. By 1900, more than 1,000 golf courses dotted the United States, made possible by new streetcar lines that allowed players to travel to the outskirts of cities, where land for golf was plentiful. Designed by the prolific Tom Bendelow, the Lakewood Country Club exemplified this trend when it was laid out along the Denver and Intermountain streetcar line between Denver and Golden. The club was formally founded in 1908, primarily by golfers from Overland. (*Golfer Magazine*, November 1910.)

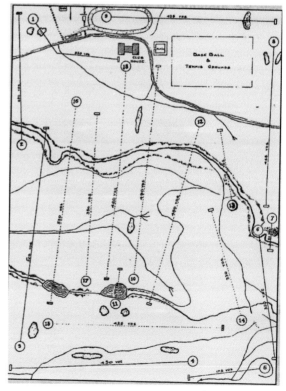

THOMAS BENDELOW, 1910. Thomas Bendelow, a Scottish American, was known as the Johnny Appleseed of golf. Bendelow's career was spent primarily with the A. G. Spalding Company, traveling the United States promoting golf, staging exhibitions, and designing and building golf courses. Bendelow's design philosophy was to layout and build a basic course at an inexpensive price. Dirt tee boxes, sand greens, and few bunkers were the norm, with turf fairways optional. If the club was successful, it could add amenities and design features. Revisited by architects and critics in the 21st century, Bendelow's work is being reviewed more favorably in light of his minimalist philosophy. Bendelow designed the original nine holes at Colorado Golf Club in 1908 (renamed Lakewood Country Club in 1910), the Denver City Park Golf Course in 1912, and the 1920 Boulder Country Club course. (Stuart Bendelow.)

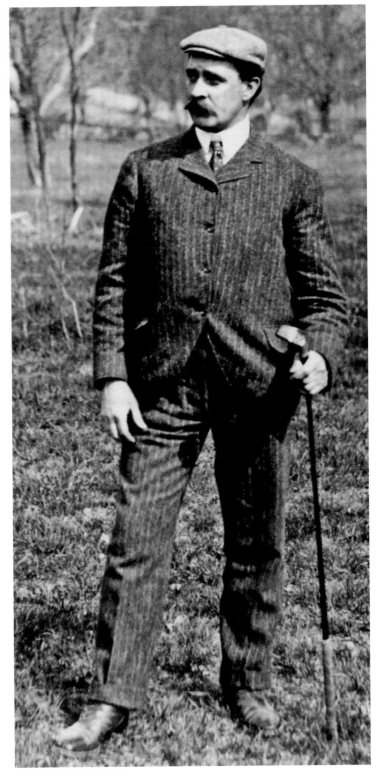

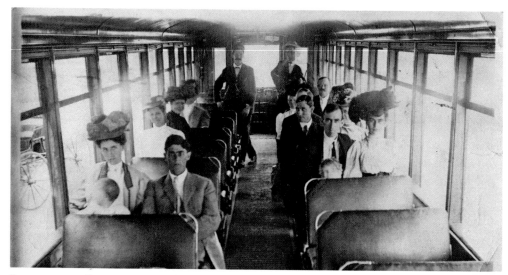

INTERIOR OF STREETCAR, 1907. Prior to the automobile becoming the dominant form of transportation in the 1920s, the streetcar was the transport of choice for those not wealthy enough to possess a horse and carriage. In order to survive, a golf course needed to be near a streetcar line or interurban railroad to transport golfers to the course. This postcard shows the interior of a Denver Tramway streetcar in 1907. (Rob Mohr.)

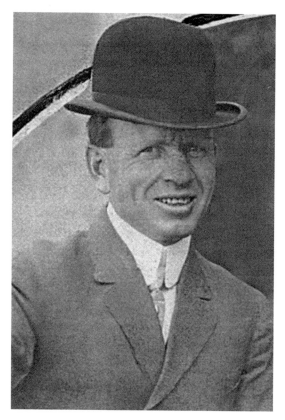

MICHAEL A. "MAC" MCLAUGHLIN. Lakewood Country Club founders such as Michael "Mac" McLaughlin ensured that their club attracted serious golfers, an unusual mission at the time. The underlying purpose of the club was reflected in the original name, the Colorado Golf Club. McLaughlin was a colorful investment banker who became the first president of the Colorado Golf Association when it was formed in 1915. Over the next decade, McLaughlin established himself as one of the top two amateur golfers in Colorado. (LCC.)

THE EARLY YEARS: 1885–1919

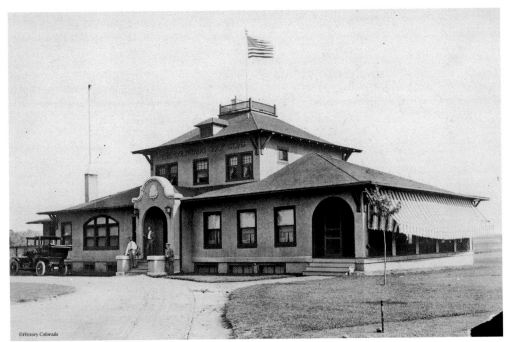

FIRST LAKEWOOD COUNTRY CLUB CLUBHOUSE, 1910. The first Lakewood Country Club Clubhouse was built in 1910 in a Mission Revival style. Still known as the Colorado Golf Club, the clubhouse gave members impetus to formally become a country club in 1912. Tragedy struck for the first but not the last time in June 1913, when the clubhouse burned to the ground. (CHS, CHS.X7660, scan 20007660.)

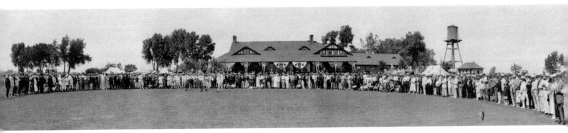

WORLD WAR I RED CROSS BENEFIT TOURNAMENT, 1915. By the beginning of World War I, the Lakewood Country Club was already one of the leading hosts for Colorado's most important golf tournaments. In the few years leading up to the United States' entry into the war, Lakewood and other golf clubs hosted many war fund-raisers, such as the Red Cross Tournament of 1915, shown here. The second clubhouse, built after the first one burned in 1913, is clearly visible. (DPL, Z-1085.)

CHARTER MEMBERS

Ambrook, A. W.
Armstrong, W. L.
Ayer. C. C.
Bergheim, J.
Buchheit, F. J.
Bromley, C. C.
Butsch, Chas. A.
Beattie, W. L.
Baur, W. F.
Brewster, Jas. H.
Bushee, F. A.
Buckingham, C. G.
Burnett, Clough T.
Chenault, L. E.
Casaday, H.
Coulehan, C. E.
Callahan, G. A.
Cole. L. W.
Coolidge, Cole
Derham, Milo G.
DeLong, Ira M.
Dickson, M. J.
Ekeley, J. B.
Evans, H. S.
Eastman, Frank
Fine, E. G.
Francis, Wm.
Fitzpatrick, T. H.
Fair, E.
Farrand, Livingston
Gamble, Harry P.
Greenman, Alfred A.
Grill, Ernest
Goss, M. C.
Gillaspie, C.
Gilbert, O. M.
Herman, Louis
Hellems, F. B. R.
Howard, I. C.
Holmes, Horace B.
Hahn, A. W.
Hankins, James C.

Harlow, W. P.
Hunter, J. A.
Huntington, W. C.
Jackson, B. H.
Joslyn, R. W.
Kingsbury, S. S.
Ketterman, W. E.
Kohler, F. W.
Lang, James A.
Lester, O. C.
Libby, M. F.
Linsley, Chas. F.
Linsley, Everett
Loach, Wm.
McHarg, T. A.
McFayden, D.
McLeod, W. H.
McKenzie, Neil B.
Monroe, Chas. A.
Moorhead, J. I.
Myers, D. J.
Norlin, Geo.
Overfelt, L. B.
Osborn, Loran D.
Peebles, A. R.
Pease, Wm. H.
Parkhurst, A. A.
Reed, Albert A.
Robertson. E. H.
Riley, H. L.
Sloan, Foreman
Sperry, C. S.
Smith, C. Henry
Tedrow, Harry B.
Valentine. J. W.
Wallace, H. U.
Ward, A. E.
White, W. W.
Woodbury, H. S.
White, Fred
Washburn, H. C.
Wolf, J. R., Jr.

Boulder Golf Club

OFFICERS 1914

President, T. A. McHARG

Vice-President, H. P. GAMBLE

Secretary, C. F. LINSLEY

Treasurer, LOUIS HERMAN

Captain, C. HENRY SMITH

DIRECTORS

TERMS EXPIRING 1915

O. C. LESTER C. HENRY SMITH
 C. F. LINSLEY

TERMS EXPIRING 1916

J. L. MOORHEAD LOUIS HERMAN
 W. L. ARMSTRONG

TERMS EXPIRING 1917

T. A. McHARG H. P. GAMBLE
 H. U. WALLACE

1914 BOULDER GOLF CLUB MEMBERS BOOK. In 1912, a group of Boulder businessmen laid out a nine-hole golf course on a mesa west of the Chautauqua and incorporated as the Boulder Golf Club with 84 members. In 1917, they leased property east of Twenty-eighth Street near Kalmia Avenue to build a 3,333-yard course. The first two pages of this member's booklet from 1914 was a who's who of the Boulder business community. (CBLLHBC.)

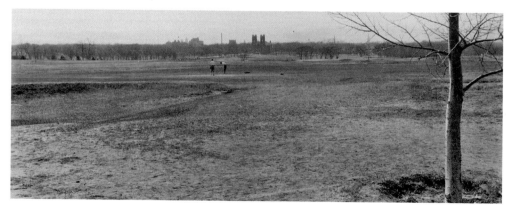

LOOKING WEST FROM CITY PARK. Officially opened in the summer of 1913, City Park Golf Course was built on land given to the city from the City Park Farm Dairy, with an additional 50 acres rented from the state. Lying a mile from the center of Denver, City Park is the closest course to the city. In this view, the spires from the Cathedral of the Immaculate Conception on Colfax Avenue are visible to the west. (DPL, No. 9.)

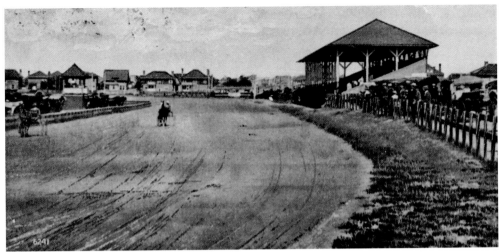

RACING AT CITY PARK, 1910. Started in 1892, the Gentlemen's Driving and Riding Club was the first established sport in City Park. As this postcard from 1910 shows, the Park Hill neighborhood was now thriving, in part due to the streetcar lines that connected East Denver with downtown and other neighborhoods. The same clientele who frequented the race tracks—sophisticated, white-collar, but not necessarily wealthy men—patronized the City Park links when they were opened in 1913. (Rob Mohr.)

CITY PARK FRIDAY AFTERNOON SKINS GAME, 1918. Since its early days, such as this Friday afternoon skins game in 1918, City Park has been known as a difficult but rewarding course. Ernie Nelson, a former City Park caddy beginning in the early 1920s, recalled, "There weren't any grass greens or grass tee boxes . . . there weren't any wooden tees, either. You grabbed a handful of sand, wet it down, and made a little mound." (DPL, F-44988.)

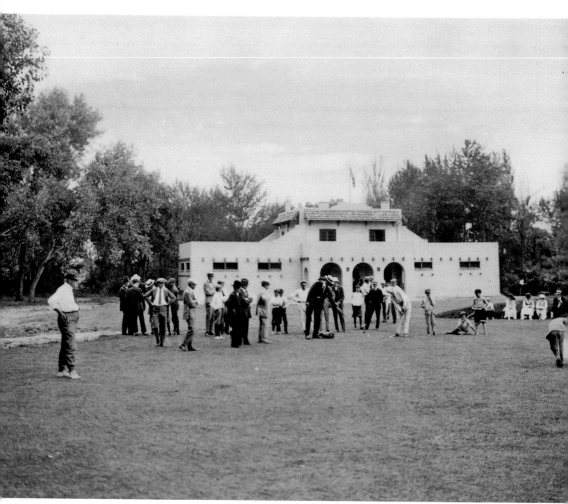

PLAYERS IN FRONT OF CITY PARK CLUBHOUSE, 1918. City Park was the first municipal golf course in Denver, and thus one of the earliest courses to attract middle-class players instead of only the socially elite. For the first five years, City Park Golf Course players went without a clubhouse. This photograph from 1918 shows the original clubhouse, finally erected that same year in a Moorish design. (DMF, May 1923, courtesy of DPL.)

LAKEWOOD COUNTRY CLUB AND COLORADO SPRINGS GOLF CLUB. The Denver and Lakewood Country Clubs formed women's teams in the early 1910s to compete with women's teams from City Park Golf Course and Colorado Springs Golf Club. At right are women contestants at the 1912 State Championship, held at Lakewood Country Club. Women were an integral part of most country clubs. The Colorado Women's Golf Association was formed in 1916, with the first official Women's Amateur Championship held that year at Colorado Springs Golf Club, shown below in a 1908 postcard. Twenty-eight women participated with, Mrs. M. A. McLaughlin winning. (Right, LCC; below, Rob Mohr.)

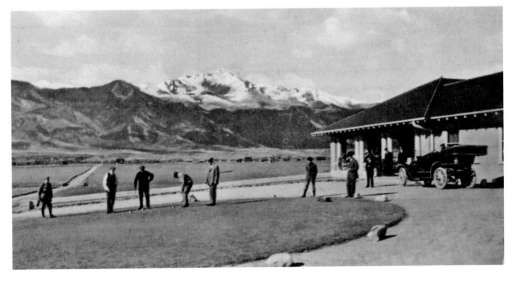

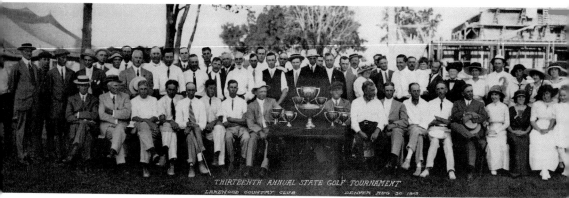

THIRTEENTH ANNUAL STATE GOLF TOURNAMENT
LAKEWOOD COUNTRY CLUB DENVER AUG 30 1913

LAKEWOOD COUNTRY CLUB, 1913. Contestants and their families gather for a group photograph at the 1913 Colorado Golf Championship, held at Lakewood Country Club. In 1901, Overland Country Club hosted the first state championship. With the organization of the Colorado Golf Association in 1915, the responsibility for putting on a statewide championship (as well as standardizing rules) fell to the new association. Seated to the left of the trophy table in the bucket hat is M. A. "Mac" McLaughlin of Lakewood Country Club; to the right of the trophy table in the white shirt is Walter Fairbanks of the Denver Country Club; and in the second row standing at left center with the white beard is A. G. Brooks of the Interlachen Golf Club. In the background, the new Lakewood Country Club clubhouse is under construction. (LCC.)

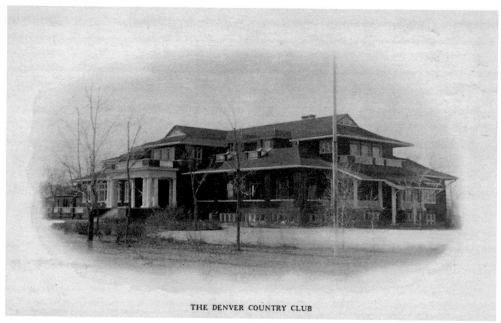

THE DENVER COUNTRY CLUB

DENVER COUNTRY CLUB POSTCARD, C. 1905. In 1903, work began on roads and course construction at the site of the new Denver Country Club. Within two years, the country club completed a sophisticated clubhouse at the cost of $20,000. The gabled frame building is reminiscent of the luxurious yet relaxed style admired in the East Coast resorts. (Rob Mohr.)

THE GAME GROWS
1920 – 1929

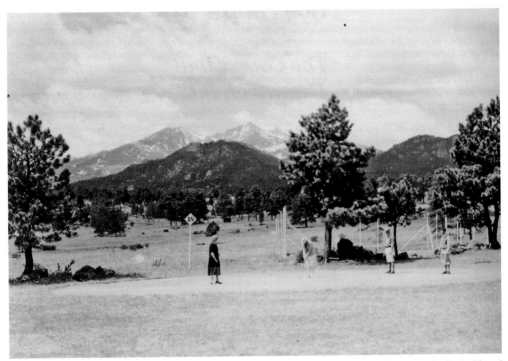

ESTES PARK GOLF AND COUNTRY CLUB 1920. Throughout the 1920s, the Estes Park Golf and Country Club primarily attracted seasonal residents and tourists. This photograph of the 18th green in 1920 shows the beautiful mountain setting of the course. At the time, Estes Park Golf and Country Club was owned by the Estes Park Improvement Association and was open to the public. Locals regularly assisted in clean up of the course at the beginning of each season. (Estes Park Museum.)

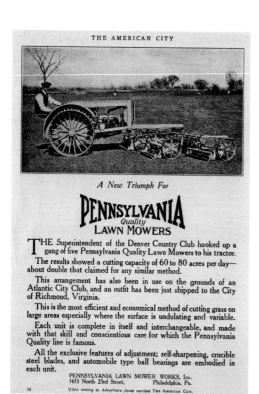

MOWER ADVERTISEMENT, 1920. This ad for a tractor-operated gang mower is from 1920 and touts Denver Country Club as a customer. With the advent of affordable motorized tractors around 1910, golf courses could be mowed closer and in less time than with horse-drawn mowers, and they were far superior to the 19th-century practice of grazing goats to maintain fairways. (Rob Mohr.)

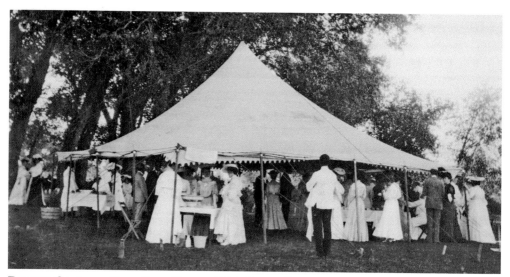

DENVER COUNTRY CLUB TENT PARTY, 1928. Originally a nine-hole course, the Denver Country Club golf course was redesigned by William S. Flynn during 1923 and 1924 and remained relatively unchanged until the mid-1950s, when East First Avenue was widened. During the first half of the 20th century, the Denver Country Club was the host for tournaments such as the Trans-Mississippi Amateur (1910), Western Golf Association Amateur (1912), and Women's Trans-Mississippi (1936), and was home to several trophy-winning players, such as Walter Fairbanks, Dr. Lawrence Bromfield, and Ruth Harrison. (*Golf Illustrated*, 1928.)

Tom O'Hara with Sons, c. 1925. In 1910, while visiting Apawanis Country Club in Brooklyn, New York, Frank Woodward (then president of the Denver Country Club) discovered a talented caddy master named Tom O'Hara. Seen here with his sons, O'Hara possessed such skill that Woodward convinced O'Hara to move to Denver and work for the Denver Country Club. Over his 51-year career, O'Hara became one of the most respected golf professionals in the nation, training over 40,000 caddies. (CGA.)

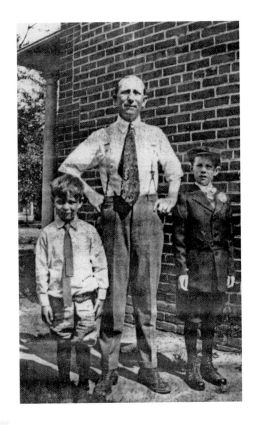

CADDY MASTERS INSTRUCTIONS

Caddies age, name and address should be registered in a book.

Each caddy should be numbered and placed in the class they belong, according to their experience as a caddy. First class from No. 1 to 100, second class No. 101, etc.

First class caddies are paid 25 cents per hour. Second class caddies are paid 20 cents per hour.

Caddies disobeying rules are laid off for one week to one month, according to which rule they disobeyed, and placed in second class, for third offence discharged.

Caddies are placed in class according to reports from members, and as Caddy Master judges the improvement of the caddies.

Caddies should be taken out on Golf Course once a week and instructed by Caddy Master what to do and where to stand.

Caddies should be taught politeness and manners by Caddy Master.

The instructions to caddies should be read and explained to all caddies every morning.

Caddies should be told to address members by Mr. and Mrs. and Miss and should answer Yes Sir, Yes Mam, which will help the game and the boy.

If a caddy takes a ball or Golf Club he should not be discharged, he should be told where he is wrong and given a chance to do right. I have had a number of boys do wrong and turned them on the right way in my experience of boys in my 52 years as a Caddy Master.

Caddy Masters should co-operate with school authorities by not employing school boys during school hours; and school authorities with Caddy Masters by excusing caddies for Special Occasions.

Yours truly,

TOM O'HARA, Caddy Master
The Denver Country Club.

Tom O'Hara Caddy Rules. He created an annual caddie tournament that was copied by other clubs across the country, and he wrote the unofficial caddie rules, which are still respected and used often today. O'Hara refused to ever copyright the rules, stating that "I want them to be used by everybody." Tom O'Hara is an honored inductee into the Colorado Golf Hall of Fame. (CGA.)

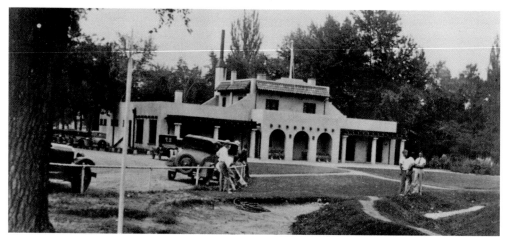

CITY PARK CLUBHOUSE, 1923. This Harry Rhoads photograph from 1923 shows the new addition to the City Park clubhouse in the rear to accommodate growing crowds. During the 1920s, golfers would wait upwards of three hours to play at busy times, and the crowd was the most diverse in Denver. Once City Park converted its sand greens and clay tee areas with grass and rubber mats in 1928, it became the most popular course in the city. (DPL, RH-22.)

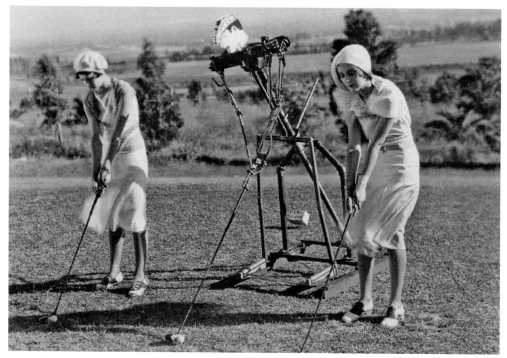

TWO WOMEN WITH A TRAINING MACHINE, 1920S. Women played golf since its inception in Europe; even Mary Queen of Scots was known to golf during the mid-1500s. A dichotomy existed for much of the 20th century as golf gained popularity. Women were encouraged to golf, yet they were only permitted to play during off-peak hours. The Ladies Professional Golf Association (LPGA) wasn't even founded until 1950. (Rob Mohr.)

DENVER GOLF DAYS, 1920–1946. Tom O'Hara, renowned caddy master at Denver Country Club, recorded the weather in Denver over a 26-year period. Not only was 1929 a hard year for the economy, but it also appeared to be the worst for weather as well. O'Hara's observations illustrate how compatible Denver's climate really is for the sport. (CGA.)

By Tom. O'Hara.
Golf. Days. Records & in Denver. Colo. 1920.

YEAR	DAYS-GOLF PLAYED	NO GOLF
1920	300	65
1921	310	55
1922	320	45
1923	285	80
1924	282	84
1925	313	52
1926	280	85
1927	301	64
1928	288	78
1929	258	107
1930	291	74
1931	290	75
1932	305	61
1933	323	37
1934	326	39
1935	342	23
1936	323	43
1937	299	66
1938	301	64
1939	307	58
1940	288	78
1941	325	40
1942	279	86
1943	328	37
1944	275	91
1945	307	58
1946	308	57
1947		
1948		

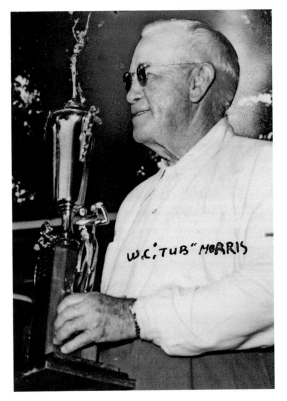

N. C. "TUB" MORRIS. N. C. "Tub" Morris was an example of the new kind of golfer who emerged as the sport became more popular among all classes. Morris was an accomplished amateur based out of the Lakewood Country Club. A board member for the Colorado Golf Association, he won the Broadmoor Invitational and two State Match Play Championships during the 1920s. Yet Morris earned a living as a history teacher at West High School in Denver. (CGA.)

BOULDER COUNTRY CLUB NEW CLUBHOUSE, 1920. Boulder Golf Course reformed as the Boulder Country Club in 1919 and began construction on a clubhouse at Twenty-eighth Street and Kalmia Avenue. The clubhouse, built of native stone, opened in 1920. Boulder Country Club used the building until 1935. In 1948, the building was converted to a private residence. The city of Boulder designated the house as a Historical Landmark in 1993. (CBLLHBC.)

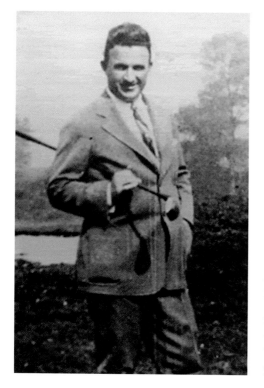

WILLIAM FLYNN. In the 1920s, William Flynn was a nationally recognized golf course architect whose courses at Merion, Shinnecock Hills, and Cherry Hills would host numerous major championships. Flynn's Cherry Hills design opened to rave reviews and has hosted three U.S. Opens, two PGA Championships, and five other USGA Championships. Flynn was paid $4,500 for his services. (*American Golfer.*)

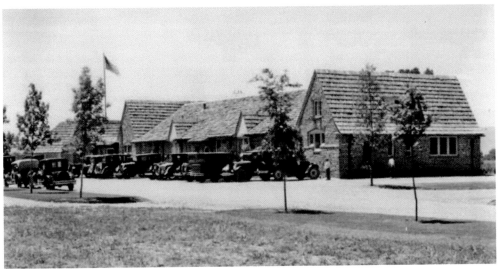

CHERRY HILLS COUNTRY CLUB CLUBHOUSE, MID-1920S. By 1920, Denver Country Club was well established as a component of Denver's high society. With over 500 members actively involved in golf, tennis, swimming, and a whirlwind of social activities, several scions of the club embraced the idea of a simpler club for men and golf only. From that idea sprang Cherry Hills Country Club. The clubhouse, designed by Hoyt and Hoyt Architects, was completed in 1922. (DPL, MCC-2833.)

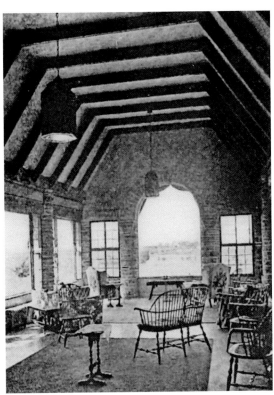

VERANDA AT CHERRY HILLS COUNTRY CLUB. Architects Merril and Burnham Hoyt included this open-air veranda in the design of the Cherry Hills clubhouse. Following the club's golf-only intent, they did not include a swimming pool or tennis courts. The Great Depression of the 1930s led the club to add those amenities in order to attract and keep families. Burnham Hoyt went on to an acclaimed career in New York City and Europe. (*Golf Illustrated*, 1928.)

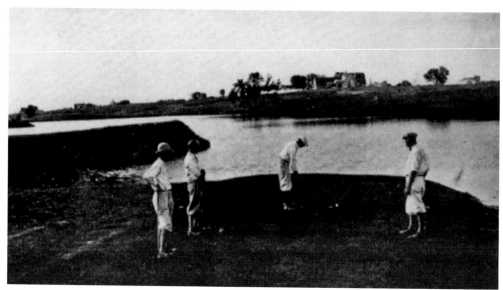

THE 18TH HOLE AT CHERRY HILLS COUNTRY CLUB. The tee shot on the 18th hole at Cherry Hills Country Club presents a formidable challenge to these golfers in 1928. The 18th hole played a role in deciding several major championships, including the 1941 PGA Championship, the 1960 U.S. Open, the 1978 U.S. Open, and the 2005 U.S. Women's Open. The clubhouse can be seen on the rise behind the 18th green. (*Golf Illustrated*, 1928.)

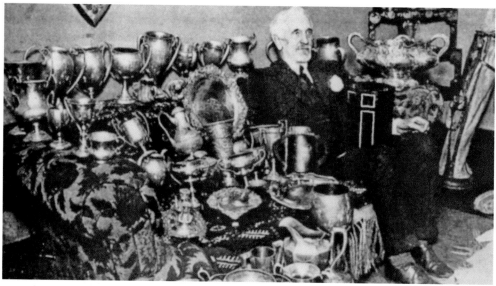

WALTER FAIRBANKS RETIRES. Walter Fairbanks sits among his trophies and medals won over a 35-year amateur career at his retirement party in January 1924 at the Denver Athletic Club. Fairbanks was in failing health at the time and died in April 1924 in England. Fairbanks was Colorado amateur champion four times, Southern California amateur champion three times, Pacific Coast champion once, and Southern Florida champion four times. (*American Golfer*, February 1924.)

DONALD ROSS. Donald Ross, along with A. W. Tillingast, Dr. Alister MacKenzie, William Flynn, Charles B. Macdonald, and Harry Colt, was among the well-known golf course architects from the golden age of course design, approximately 1900 to 1929. Ross's firm designed the Wellshire Country Club course between 1925 and 1926. Ross himself didn't visit the site, but his top assistant, Walter P. Hatch, made several on-site appearances. (Tufts Archive.)

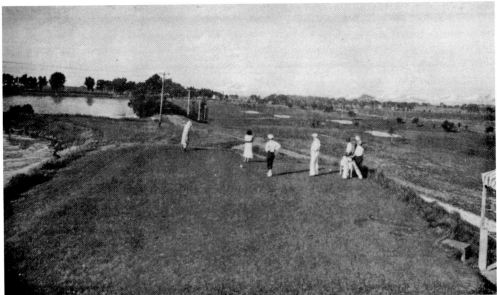

WELLSHIRE FAIRWAY FIRST HOLE, PAR FIVE. On August 28, 1926, the Wellshire Country Club was opened 4 miles south of Denver on a 137-acre farm. Donald Ross designed a prestigious course, incorporating an existing lake and irrigation canal (now known as the Highline Canal). Membership was limited to 400 people. This photograph of the first fairway shows how ideal the land was for golf. (CPGC.)

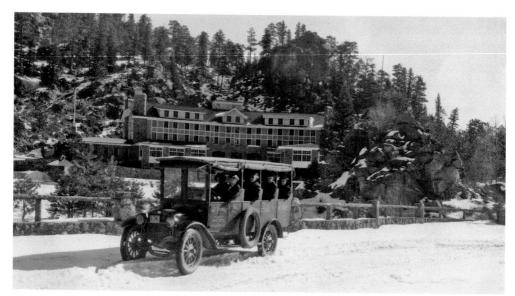

TROUTDALE IN THE PINES RESORT, 1924. A shuttle bus pulls up in front of the Troutdale in the Pines Resort in winter 1924. Nebraska automobile dealer Harry Sidles built the resort just west of Evergreen on Upper Bear Creek Road in 1919. Troutdale catered to a wealthy clientele, including Hollywood celebrities Clark Gable, Douglas Fairbanks, Jack Benny, and Greta Garbo. By 1919 (possibly as early as 1914), Sidles had built a nine-hole golf course near the hotel. (JCHS and Hiwan Homestead Museum.)

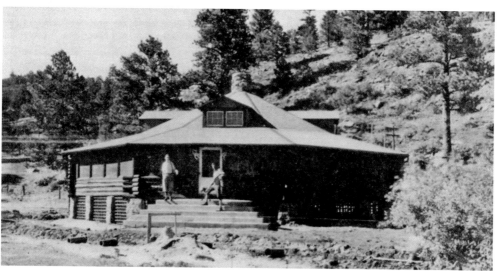

CLUBHOUSE AT EVERGREEN MUNICIPAL GOLF COURSE. Two men stand on the steps of the nearly completed clubhouse at Evergreen Golf Course in 1925. Denver acquired the De Disse ranch property in 1919 with the intention of building a dam on Bear Creek and forming a reservoir/recreational lake in the valley. In 1925, Denver built a nine-hole course on the property. In 1926, Harry Sidles deeded nearly 18,000 acres to the City of Denver, including the Troutdale golf course. (DMF, May/June/July, 1926.)

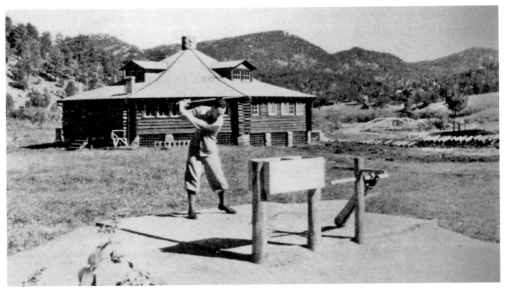

EVERGREEN MUNICIPAL GOLF COURSE, 1926. A golfer tees off in 1926 on the first hole in front of the recently completed clubhouse at Evergreen Golf Course. Jacques Benedict, a prominent Colorado architect, designed the polygonal building. Irrigation pipes and construction material can be seen in the background. The municipal course was expanded to 18 holes in 1926, with the addition of the Troutdale in the Pines nine-hole course. (DMF, March/April 1926.)

WOMEN APPROACH A SAND GREEN AT EVERGREEN, 1920S. Two women approach a sand green at Evergreen Municipal Golf Course in the late 1920s. Denver Parks and Recreation had nearly given up on Evergreen Golf Course by the 1980s, when Babe Lind, the city's director of golf, pushed hard for a remodel, believing the course could become the mountain jewel of the Denver municipal golf system. By 1984, the course was rerouted and all of the sand greens were replaced by grass. (DPL, F-31488.)

WOMEN AT EVERGREEN, C. 1928. Three women and a caddy watch as another woman tees off from a rocky elevated tee box at Evergreen Municipal Golf Course in the late 1920s. Denver municipal golf rules are posted on the sign. (DMF, courtesy of DPL.)

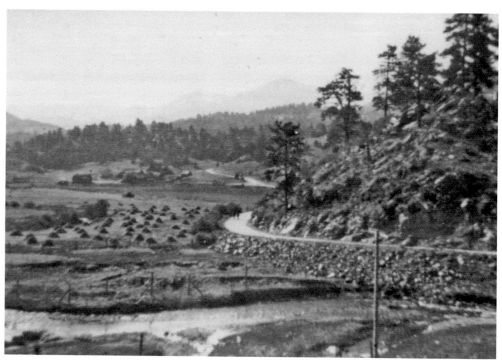

DE DISSE RANCH VALLEY, 1925. This is the De Disse ranch in 1925, prior to the building of the dam on Bear Creek in 1929. Ranch buildings can be seen on the far side of the valley. Upper Bear Creek Road is on the right, with the golf course clubhouse located around the last bend in the road. Bear Creek is in the forefront, near where the dam is now located. (JCHS and Hiwan Homestead Museum.)

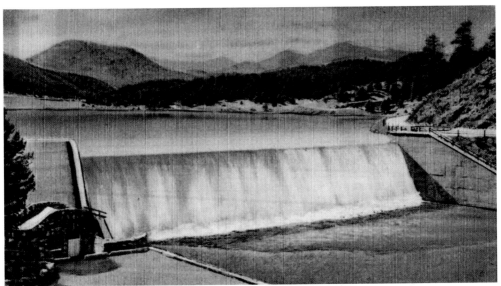

EVERGREEN LAKE DAM. Evergreen Lake and dam are shown in a postcard from the early 1930s. Evergreen Lake was formed in 1929, when the dam was built by the City of Denver. Evergreen Golf Course is located on the far side of the lake. The dam has been an effective flood control tool, and the lake and surrounding Denver Mountain Park have been a hugely successful recreational destination for fishing, hiking, golf, and ice-skating. (Rob Mohr.)

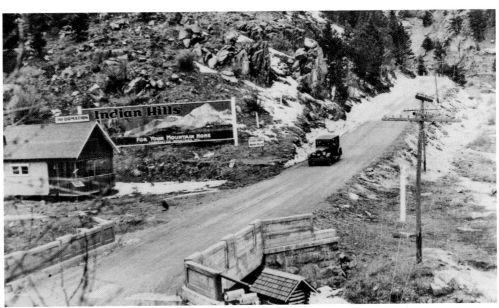

ENTRANCE SIGN TO INDIAN HILLS, 1920s. Indian Hills is a mountain community located in Parmalee Gulch, west of Denver. George Olinger, of Olinger Mortuaries, originally developed Indians Hills as a community of summer cabins on 60-by-100-foot lots. Over the years, Indian Hills cabins have been enlarged and upgraded to year-round residences. (JCHS and Hiwan Homestead Museum.)

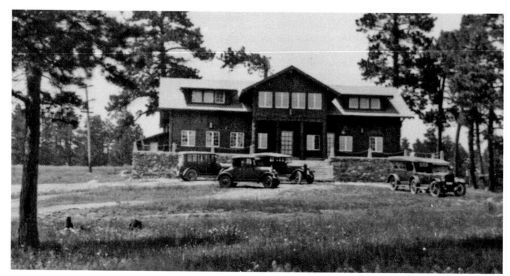

INDIAN HILLS COUNTRY CLUB CLUBHOUSE. George Olinger, thinking a golf course could attract potential buyers to Indian Hills, built a nine-hole course with a two-story rustic clubhouse in 1924. Memberships were given to Denver Motor Club members and purchasers of lots in the development. The 2,500-yard course was attractive to golfers from Denver, who filled the course on weekends. The course was abandoned in the early 1930s, during the depth of the Great Depression. (JCHS and Hiwan Homestead Museum.)

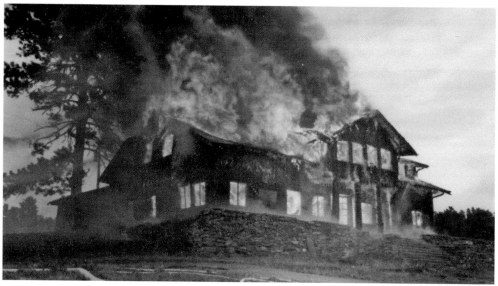

INDIAN HILLS CLUBHOUSE ENGULFED IN FLAMES, 1986. Having been used as pastureland for 30 years, what little trace of Indian Hills golf course that remained disappeared in 1962, when the Alpine Village development was built on the site. In 1986, the derelict Indian Hills clubhouse was turned over to the Indian Hills Fire Department to burn down in a controlled fire training exercise. In this photograph, the clubhouse is fully engulfed in flames. (JCHS and Hiwan Homestead Museum.)

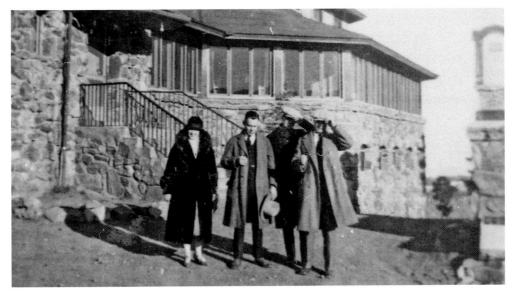

MOUNT VERNON COUNTRY CLUB, 1924. Mount Vernon Country Club opened in 1924 with a large stone clubhouse and an 18-hole golf course. In this photograph are, from left to right, Mrs. Cook, Mr. Lever, Jack Foster, and Max Cook. The golf course was abandoned during World War II due to indifference by club members and high maintenance costs. An attempt was made to revive the golf course in 1949, but it failed after one season. (JCHS and Hiwan Homestead Museum.)

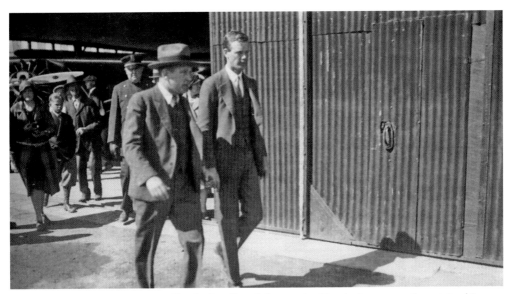

LINDBERGH AT LOWRY FIELD. Charles Lindbergh leaves the Combs hangar at the original Lowry field in northeast Denver on August 31, 1927. The airfield was adjacent to the property that would become Park Hill Golf Course. Touring the United States, Lindbergh spent the night at the Brown Palace hotel, while the *Spirit of St. Louis* spent the night at the Combs aircraft hangar. The hangar is still visible from the sixth hole on the eastern side of the Park Hill Golf Course. (DPL, RH-76.)

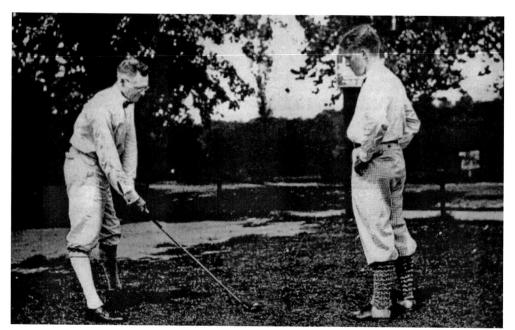

BOBBY JONES AND O. B. KEELER. Robert "Bobby" Jones was the most famous golfer in the world in the 1920s. A committed amateur, Jones's personality and skill endeared him to the public at large outside of golf. His popularity fueled nearly a decade of growth in golf participation during the 1920s. In the Denver area, the growing popularity of golf led to overcrowded conditions on all courses. Jones is shown here in 1928 observing sportswriter O. B. Keeler's swing. (*American Golfer*, August 28, 1928.)

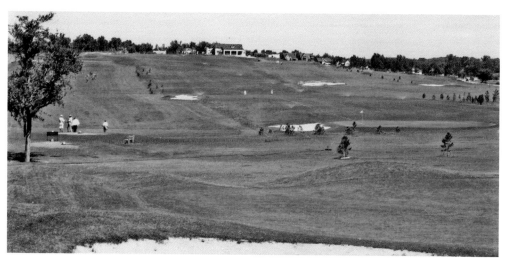

BERKELEY PARK MUNICIPAL GOLF COURSE. By 1922, Interlachen, now known as Rocky Mountain Country Club, had sold off its property on the west side of Sheridan Boulevard. In 1924, the failing club sold the remaining nine-hole course to the El Jebel Shrine. Denver built a new nine-hole course north of Berkeley Park, adjacent to the El Jebel Shrine course, in 1929. The view in this photograph is to the east with the new clubhouse at the top of the hill. (DPL, MCC-3097.)

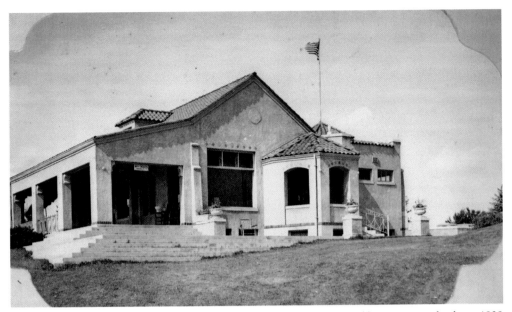

BERKELEY PARK CLUBHOUSE. The clubhouse at Berkeley Park Golf Course was built in 1929 and was in service for 80 years. The building featured a stucco finish, tile roof, and an open-air veranda. The sign says, "Buy Tickets Inside." The nine-hole course at Berkeley Park Golf Course was Denver's third municipal golf facility, following City Park in 1912–1913 and Evergreen Municipal Golf Course in 1925. (DPL, X-20295.)

DENVER CITY MAP, 1930. By 1930, the Rocky Mountain Country Club was no longer in operation. The El Jebel Shrine continued operating the nine-hole course under the El Jebel Shrine name, as shown on this Denver City map from 1930. The nine-hole Berkeley Park Golf Course is identified as the City Golf Links. (DPL, X-20295.)

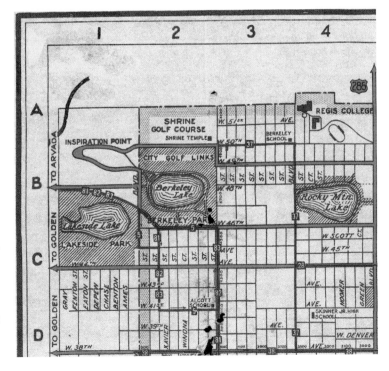

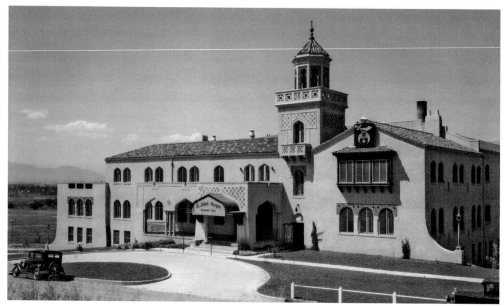

EL JEBEL SHRINE MOSQUE, 1930. The El Jebel Shrine purchased the Rocky Mountain Country Club property in 1924. The shrine built its new mosque and parking lot on 5 acres of the property at Fiftieth Avenue and Vrain Street, leasing back the golf course to the Rocky Mountain Country Club group. The mosque opened in November 1929, shortly after the stock market crashed in October. The new mosque is shown in a postcard from 1930. (DPL, photograph by L. C. McClure, MCC-2099.)

VIEW FROM BERKELEY LAKE. This view looking north from the western edge of Berkeley Lake shows the Berkeley Park Golf Course, the El Jebel Shrine Mosque in the background on the left, and the new clubhouse at the top of the slope in the center. Berkeley Park Golf Course was the last Denver municipal course built using horse-drawn equipment and manual labor, with as little dirt being moved as possible. (DPL, Photograph by L. C. McClure, MCC-3098.)

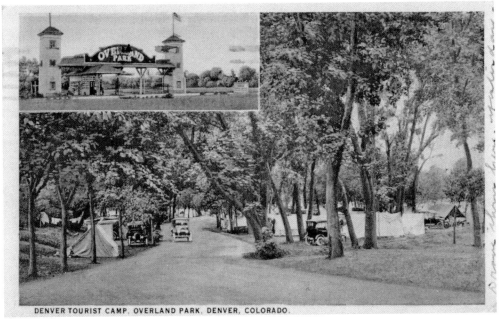

DENVER TOURIST CAMP, OVERLAND PARK, DENVER, COLORADO.

PARK TOURIST CAMP POSTCARD, 1924. Denver purchased Overland Park in 1919, including the 1908 Exposition and Fair buildings, the racetrack, and the stables. By 1921, with the economy booming and automobiles affordable to the middle class, hundreds of thousands of Americans were on the road touring the United States. To meet this demand, the City of Denver transformed the park into a tourist camp, complete with gas station, playgrounds, billiard room, restaurant, grocery store, dry goods store, barbershop, laundry facilities, and ballroom. (Rob Mohr.)

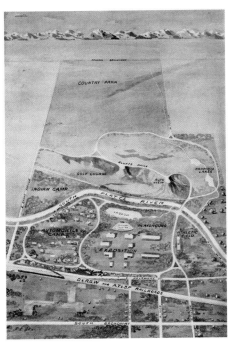

PROPOSED PLAN FOR OVERLAND PARK, 1925. A plan to create a large recreational area at Overland Park was proposed in 1925 and included a scenic boulevard with overlook on Ruby Hill, a golf course on the west side of the South Platte River, athletic fields, and the existing auto park and exhibition buildings. By 1930, the proposal had been scrapped in favor of building a nine-hole course, opened in 1932. (DMF, January 1925.)

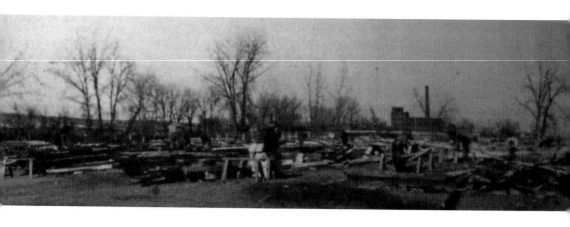

BUILDINGS AT OVERLAND BEING DEMOLISHED. By 1929, improved roads with motels, gas stations, restaurants, and other services had reduced the need for tourist camps like Overland Park. Denver closed the tourist camp that year and began demolishing the buildings standing on the property. The photograph above shows rubble from demolition. The photograph below shows the cleared property. By 1930, Denver had plans to build a golf course on the site. (DMF, January/February 1931.)

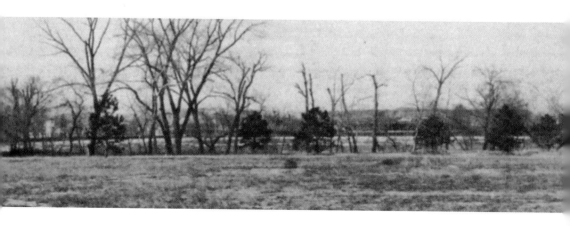

3

THE LEAN YEARS
1930–1945

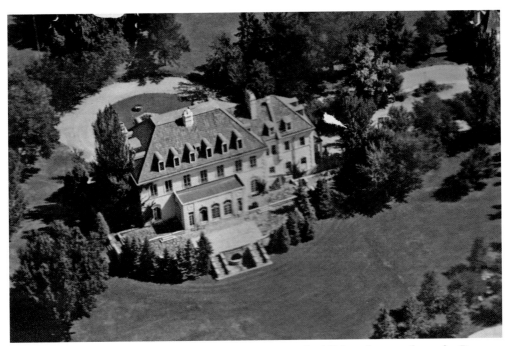

GREEN GABLES AERIAL VIEW OF CLUBHOUSE, 1930. In 1928, eight men from the Progress Club, a Jewish businessmen's organization, purchased the $300,000 Reed Estate, located near the town of Midway on Morrison Road (now Jewell Avenue at Wadsworth Boulevard), for $75,000 to create a private country club. The manor house would be used as the clubhouse, with an 18-hole golf course to be built on the 140-acre property. This aerial view of the Manor House dates from 1930. (GGCC.)

SHWAYDER BROTHERS SAMSONITE ADVERTISEMENT. In this photograph touting the strength of their product, the Shwayder brothers and their father put a trunk to the test. Jesse Shwayder, second from the right, was the founder of the firm (later known as Samsonite), a member of the Progress Club, and played golf daily at City Park Golf Course in the 1920s. He was a founding member of Green Gables Country Club and served as president of the club from 1933 to 1935. (Beck Archives, CJS and Special Collections, Penrose Library, University of Denver.)

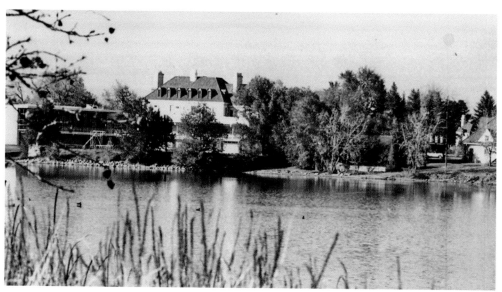

VIEW OF GREEN GABLES CLUBHOUSE FROM WARD LAKE. The Green Gables property also included a 40-acre lake. This view of the manor house is from across the lake known as Hidden Lake and Ward Reservoir. The 18-hole golf course designed by William Tucker opened in August 1930 with just nine holes completed and no sand bunkers installed yet. The bunkers were added throughout the 1930s, and the additional nine holes were completed in 1949. (Lakewood Heritage Center–Belmar Museum.)

THE LEAN YEARS: 1930–1945

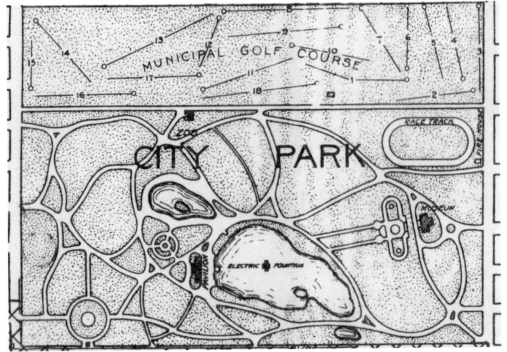

MAP OF CITY PARK, 1930. The Great Depression was challenging for golf businesses, and City Park Golf Course was no exception. Yet the City Park course remained open, as this map from 1930 illustrates. Golf was further damaged by a drought in the 1930s, which left the courses dried up and undesirable to all but the most avid players. During this time, City Park charged 50¢ per round, and an annual green fee was only $12.50. (DPL.)

PHYLLIS BUCHANAN SWINGS. During the Great Depression, Lakewood Country Club saw dwindling memberships and even installed slot machines to help cover operating costs. However, during this dark time emerged hope. The club was friendly to women golfers, a position that paid off when 19-year-old Phyllis Buchanan won her first Colorado Women's Golf Association state title. She continued to win another six times before 1939 and took the top prize at the Women's Trans-Mississippi in 1933. (CGA.)

"NATURE NEVER FORMED A LOVELIER SPOT." Estes Park, despite its attractive setting, shown here in a postcard from the 1930s, suffered during the Great Depression, particularly because its remote location was expensive to travel to. A factor in the Estes Park Golf and Country Club's survival was its participation in interclub competition with other Front Range clubs. In July 1936, it played host to the All-State Golf Tournament, attracting nearly 100 of the best regional golfers. (Rob Mohr.)

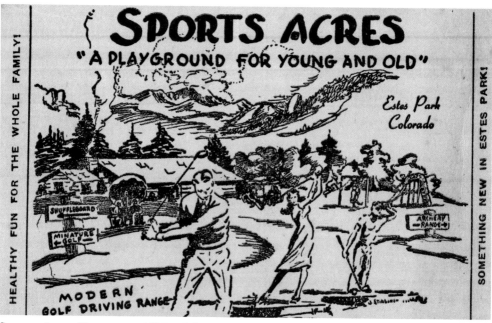

SPORTS ACRES POSTCARD, 1930s. Advertisements like this were typical as Estes Park struggled to attract visitors during the Great Depression. By 1944, the Estes Park Golf and Country Club was near bankruptcy but negotiated with the town to lease the clubhouse and grounds for 23 years. By the 1950s, the town of Estes Park had taken ownership. In the latter half of the 20th century, the Estes Park Golf Course had established itself as perhaps the oldest surviving course in Colorado. (Leslie Krupa.)

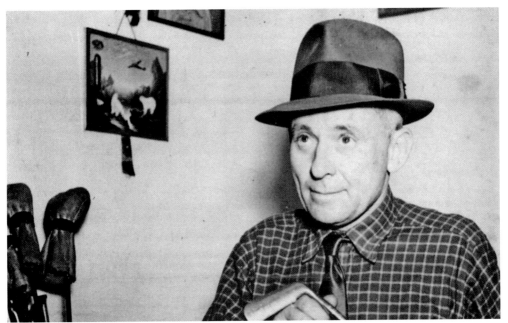

ROBERT SHEARER. Robert Shearer leased land at Thirty-fifth Avenue and Colorado Boulevard from the Clayton Trust (a trust administered by the City of Denver) and built Park Hill Golf Club in 1931. Organized as a semiprivate club, Park Hill would sell daily green fees to nonmembers. Shearer enforced his own rules and regulations regarding appropriate dress, who could play, and pace of play. Shearer is seen above in the Park Hill Clubhouse in 1938. (CGA.)

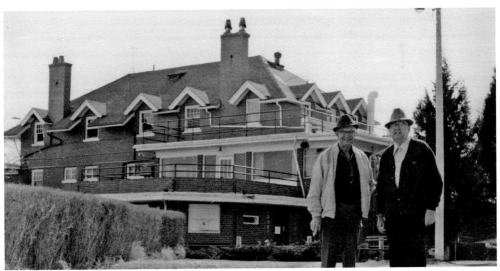

PARK HILL CLUBHOUSE. This photograph of the Park Hill Clubhouse was taken the day before it was demolished in the mid-1970s. For one week every July between 1936 to 1957, Park Hill became the gathering spot for nationally ranked amateurs and professionals, top local golfers, and celebrities such as Bob Hope when they came to play in the Park Hill Invitational. The tournament became one of the most prestigious events in Colorado. (Dan Hogan.)

NATHAN GRIMES TEEING OFF. Nathan Grimes was one of the finest amateur players in Colorado from the late 1920s through the 1940s. Grimes drew attention as a 19-year-old finishing high in the Colorado Match Play Tournament in 1927. He won the Park Hill Invitational three times, the Denver Amateur and Denver City Titles in 1930 and 1932, and the Colorado Stroke Play Championship in 1937. Grimes is shown teeing off at Park Hill Golf Club in 1935. (Dan Hogan.)

PLANS FOR PROPOSED OVERLAND PARK GOLF COURSE, 1930. This proposed plan for Overland Park Golf Course by William F. Tucker was presented to the Denver superintendent of parks in 1930 for approval. The economic depression led to severe budget cuts, with the course being scaled back to nine holes (holes 10–18 on the original plan). (*Rocky Mountain News*, December 27, 1930.)

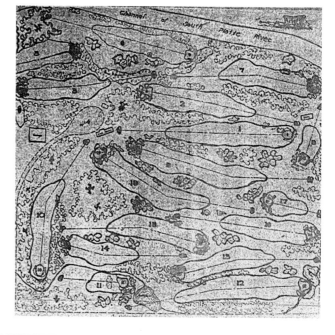

THE LEAN YEARS: 1930–1945

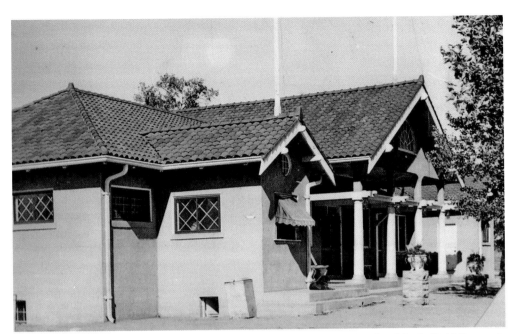

OVERLAND PARK CLUBHOUSE, MID-1930S. The clubhouse at Overland Park Golf Course is shown in the mid-1930s. The nine-hole course, located in southwest Denver, alleviated some of the congestion on the other Denver municipal courses, particularly at Interlachen/Willis Case and City Park. In 1957, an additional nine holes were added. (DPL, X-20301.)

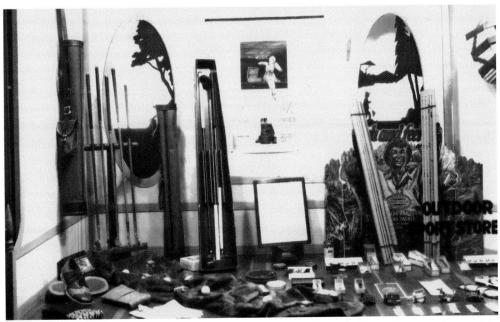

BOULDER SPORTING GOODS STORE WINDOW. Golf clubs, shoes, balls, and bags are featured in this window display of the Outdoor Sports Store at 1338 Pearl Street in Boulder, Colorado, in 1930. (CBLLHBC.)

MOUNTAIN VIEW GOLF COURSE. Raymond Austin opened the Mountain View Golf Course in Boulder in 1934. Located between Twenty-fourth and Twenty-eighth Streets south of Arapahoe Avenue, the course provided some relief to the crowded conditions at Boulder Country Club. Austin lived in a two-story brick house that also served as the clubhouse for the course. In this late 1940s view facing northwest from Twenty-eighth Street, a pickup truck drives by the eastern boundary of the course. (CBLLHBC.)

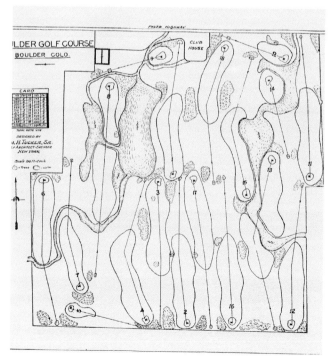

WILLIAM F. TUCKER PLAN FOR BOULDER COUNTRY CLUB GOLF COURSE. In 1933, Boulder Country Club convinced Boulder to purchase a 160-acre tract of land south of Arapahoe Avenue at Fifty-seventh Street for $12,000. The country club formed a new corporation, Boulder Municipal Sports Center, which leased the land from the city for $1 per year. The club and the City of Boulder contracted with the Works Progress Administration (WPA) to construct a golf course on the property. William F. Tucker designed the 18-hole course. (CBLLHBC.)

THE LEAN YEARS: 1930–1945

1937 SCORECARD, BOULDER COUNTRY CLUB. Construction of nine holes at the new Boulder Country Club course at Fifty-seventh Street and Arapahoe Avenue took nearly four years, as the WPA construction crews were diverted for months at a time onto other projects. In January 1937, nine holes were opened for limited play. In 1938, the nine-hole course officially opened for private and public play. This scorecard dates to 1937. (CBLLHBC.)

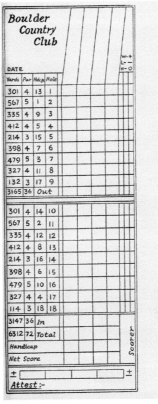

Boulder Country Club							W-+ L- H-O
DATE							
Yards	Par	Hdcp	Hole				
301	4	13	1				
567	5	1	2				
335	4	9	3				
412	4	5	4				
214	3	15	5				
398	4	7	6				
479	5	3	7				
327	4	11	8				
132	3	17	9				
3165	36		Out				
301	4	14	10				
567	5	2	11				
335	4	12	12				
412	4	8	13				
214	3	16	14				
398	4	6	15				
479	5	10	16				
327	4	4	17				
114	3	18	18				
3147	36		In				
6312	72		Total				
Handicap							
Net Score							
±							±
Attest :-							

Etiquette of Golf

Local Rules

Boulder Country Club

Boulder, Colorado

Replace Divots
Level Footprints In Bunkers
Post All Scores for Handicaps

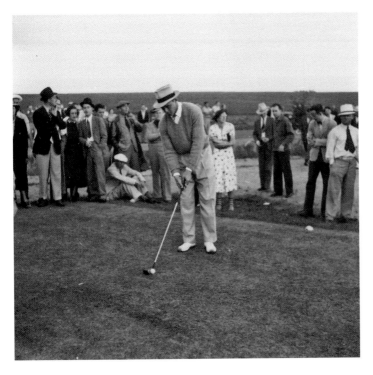

SAM SNEAD TEEING OFF AT BOULDER COUNTRY CLUB. Sam Snead tees off in an exhibition in the late 1930s at Boulder Country Club. Little is known about the exhibition, but it may have been to promote the opening of the course in the spring of 1938. (CBLLHBC.)

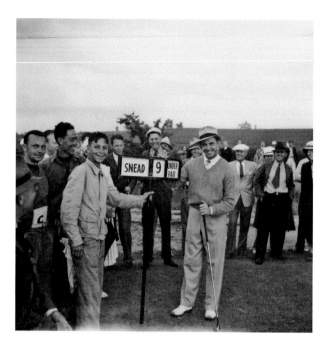

SAM SNEAD GOES NINE UNDER. Sam Snead poses with the gallery at the end of his exhibition round at Boulder Country Club in the late 1930s. The scoreboard indicates he shot nine under par, which likely set the course record. (CBLLHBC.)

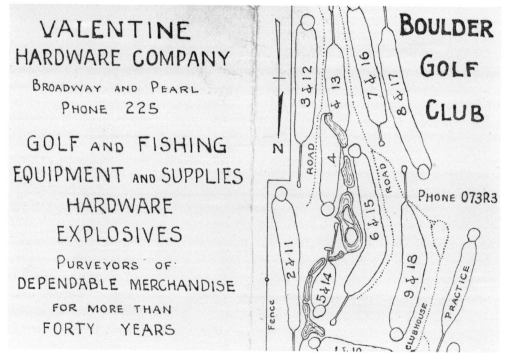

1940s SCORECARD, BOULDER COUNTRY CLUB. This scorecard from the early 1940s shows a map of the nine-hole Boulder Country Club course. Originally designed as an 18-hole course, financial pressures and the onset of World War II delayed construction of the nine holes to be located on the western portion of the property. During World War II, the vacant acreage was used to graze cattle for the war effort. In 1947, the additional nine holes were completed. (Rob Mohr.)

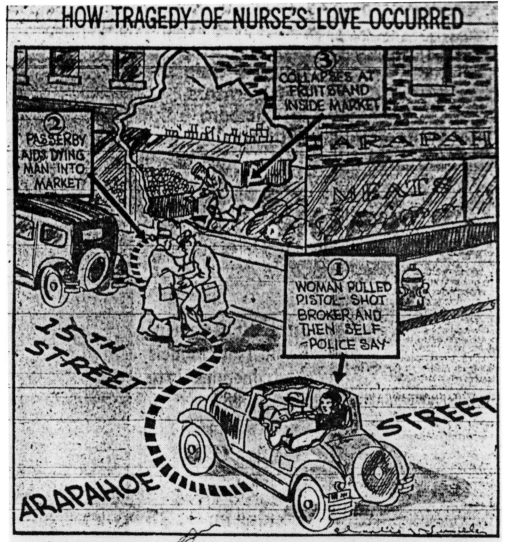

This sketch by Charles Wunder, Rocky Mountain News staff artist, shows the manner in which Willis W. Case, wealthy retired Denver business man, was shot and fatally wounded last night at 15th and Arapahoe sts., by Anna E. Wendelin, Denver nurse, who was in love with Case. Miss Wendelin then shot herself inflicting fatal wounds.

WILLIS CASE JR. MURDER. Willis Case Jr. was a wealthy stockbroker, bachelor, avid golfer, and often described as a clubman. He was a member of Lakewood Country Club, Cherry Hills Country Club, the Denver Club, and the Denver Athletic Club. On Saturday, February 10, 1934, Case was shot by his girlfriend, Anna Wendelin, while driving through the intersection of Fifteenth and Arapahoe Streets in downtown Denver. Wendelin, probably distraught over Case's refusal to marry her, then shot herself fatally in the head. Case died an hour later at the hospital. This sketch from the following morning illustrates the event. In his will, Case left about $60,000 to Denver to build a golf course. The endowment was used to purchase the adjacent Rocky Mountain Country Club/Shrine Course and merge it with the Berkeley Park Course to form Willis Case Golf Course. (*Rocky Mountain News*, February 11, 1934.)

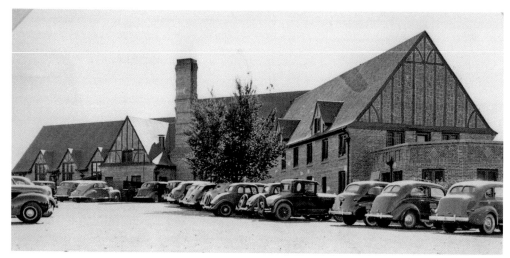

WELLSHIRE CLUBHOUSE, C. 1936. The Great Depression hit Wellshire Country Club harder than many other local clubs. Membership faltered to the point that the country club went into foreclosure. In 1936, the City of Denver purchased the course for $60,000. With the name changed to Wellshire Golf Course, the now-public course quickly became crowded again. The Wellshire neighborhood was annexed by Denver in 1950. Today Wellshire is one of the most popular and top-rated municipal courses in Colorado. (DPL, X-20336.)

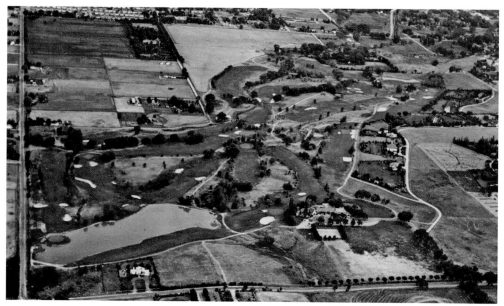

AERIAL VIEW OF CHERRY HILLS COUNTRY CLUB, 1930S. In this aerial view of Cherry Hills Country Club looking west, University Boulevard is visible at the bottom of the photograph, with the clubhouse located lower center. After World War II, the open fields surrounding the club were developed with high-end homes, and the neighborhood was incorporated as Cherry Hills Village in 1949. The island 17th green and the 18th hole parallel to the lake are shown in the lower left portion of the photograph. (Rob Mohr.)

WILL F. NICHOLSON AND CLARENCE DALY. The U.S. Golf Association awarded the 1938 U.S. Open to Cherry Hills Country Club. Never having held the open west of Minneapolis, and worried about the effects of the Great Depression on attendance, the USGA required Cherry Hills to post a $10,000 bond. This presented a problem, as club member Will F. Nicholson said: "We don't have enough money in our treasury to buy a case of ketchup." Nicholson and fellow club member Clarence Daly, a Denver insurance industry leader, solicited investments from Denver's financial community to raise the bond. Nicholson is on the right, shown in uniform following World War II in 1946, and Daly is below. (Both, CPGC.)

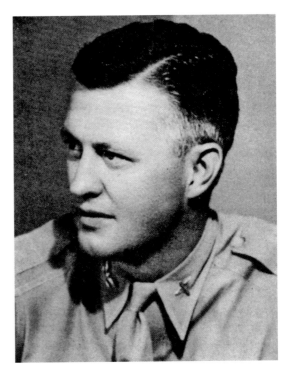

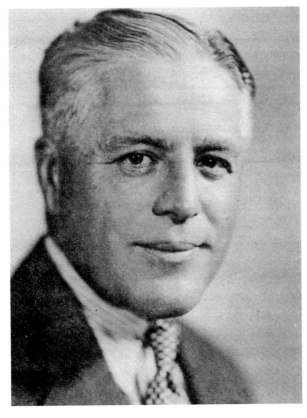

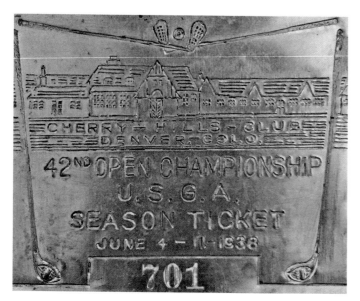

SEASON PASS TO THE 1938 U.S. OPEN. This season pass for the 1938 U.S. Open at Cherry Hills Country Club sold for $6.72 and was made of stamped pot metal. The open was a success, with attendance of 37,000. This netted Cherry Hills Country Club a profit of $23,000, proving that the club and the golf course were worthy of hosting major championships. (Rob Mohr.)

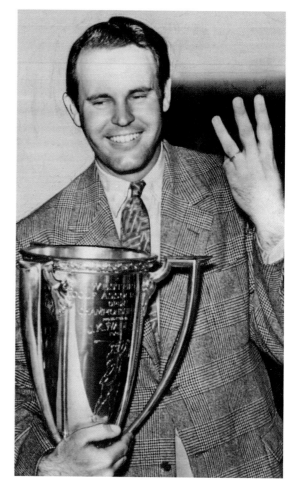

RALPH GULDAHL. Ralph Guldahl was the world's hottest golfer from 1937 through 1939. He won the U.S. Open in 1937, repeated at Cherry Hills in 1938, and won the Masters in 1939. He also won the Western Open three times, a prestigious tournament at that time. Guldahl's victory at Cherry Hills in 1938 was the last major won by a player wearing a necktie. Guldahl is shown holding the Western Open trophy in 1938. (Rob Mohr.)

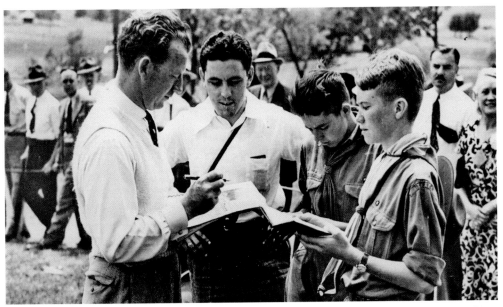

JIMMY HINES. Jimmy Hines signs autographs for two Boy Scouts at the 1938 U.S. Open. Hines had nine victories on the PGA tour in his career and finished in 11th place at Cherry Hills in 1938. The city of Denver supported Cherry Hills Country Club's efforts to promote the open, with 37,000 attending and many civic groups volunteering to help, including the Boy Scouts of Denver. (Rob Mohr.)

17TH GREEN AT CHERRY HILLS COUNTRY CLUB. In this photograph from the mid-1930s, three golfers and two caddies are shown on the 17th green at Cherry Hills Country Club. The 17th green is one of the earliest island greens, surrounded by a lake and a small waterway around the front. The par-five hole is still a diabolical challenge, despite advances in equipment and ball technology. In the 1960 U.S. Open, Ben Hogan spun a ball back off the green into the water, ending his last realistic opportunity to win another major. (Rob Mohr.)

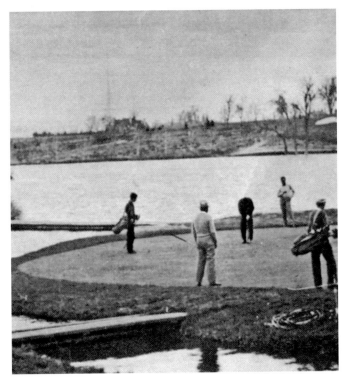

VIC GHEZZI. Cherry Hills Country Club hosted its second major, the PGA Championship, in 1941. The PGA was contested as match play until 1958, with the 1941 tournament showcasing that format. Byron Nelson and Vic Ghezzi were tied after regulation. On the second extra hole with both competitors' balls lying 2 feet from the hole, Nelson addressed his putt, but nudged Ghezzi's ball with his toe, automatically losing the hole. Ghezzi asked Nelson to continue on anyway. Nelson, rattled, missed the putt. (Rob Mohr.)

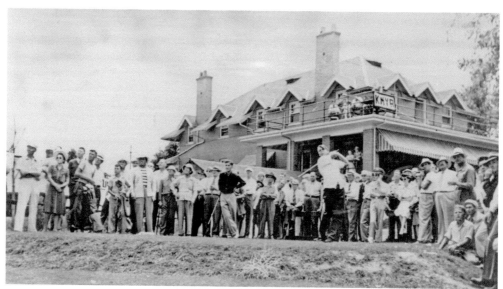

JACKIE HARTMAN. John "Jackie" Hartman was 17 years old when he won his second Colorado Junior Championship at Cherry Hills Country Club in 1941. The same day on the same course, his older brother Joseph won the Colorado Amateur Championship. Above, Jackie Hartman tees off in the final match of the prestigious 1942 Park Hill Invitational with his opponent, Babe Lind, watching. Lind prevailed in a close match. Shortly after the 1942 Park Hill tournament, Jackie Hartman joined the U.S. Marines. He was killed in action June 29, 1945, on Okinawa. (Dan Hogan.)

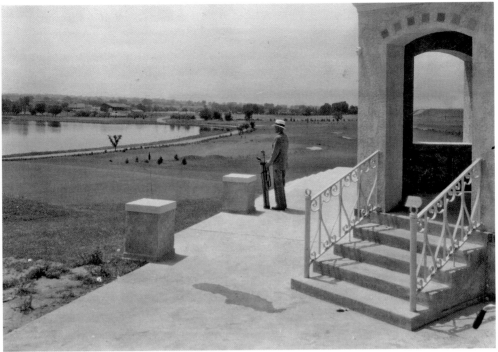

SOUTHWEST VIEW FROM WILLIS CASE CLUBHOUSE, LATE 1930S. A lone golfer stands on the clubhouse stairs at Willis Case Municipal Golf Course in the late 1930s. The view faces southwest towards Berkeley Park Lake. In 1963, Interstate 70 was built north of Berkeley Lake, dividing the golf course from the park. (DPL, F-44986.)

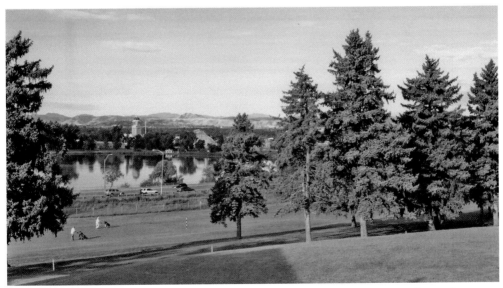

ANOTHER VIEW FROM WILLIS CASE CLUBHOUSE, 2010. The same view southwest from near the new clubhouse shows mature trees. Interstate 70, the casino tower, and the roller coaster at Lakeside Amusement Park can be seen in the background. (Ed Cronin.)

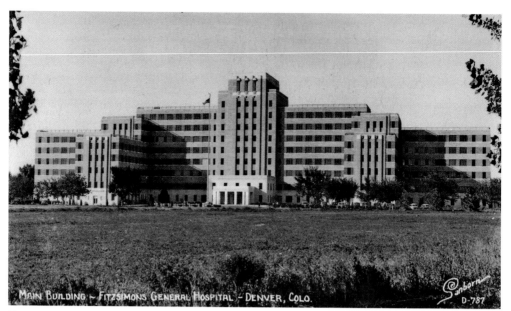

FITZSIMONS HOSPITAL, 1942. Fitzsimons Hospital was built in 1918 to serve veterans injured in World War I. There are stories of the hospital building two or three golf holes in 1919 or 1920 for rehabilitation of injured soldiers, but they remain unsubstantiated. In the ramp-up to World War II in 1938, Fitzsimons was expanded with the large central hospital building and an 18-hole golf course. (Rob Mohr.)

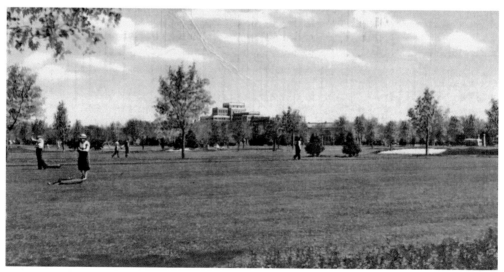

FITZSIMONS, VIEW FROM FIRST FAIRWAY, 1943. The golf course at Fitzsimons General Hospital (later Fitzsimons Army Hospital) was built in 1938 to serve patients and personnel. This 1943 postcard shows the first fairway and the main hospital building. Fitzsimons was a training facility during the war. In 1941, nearly 4,000 army recruits were instructed there. The golf course is now an Aurora municipal course, and the hospital is now the site of the Anschutz Medical Campus. (Rob Mohr.)

THE LEAN YEARS: 1930–1945

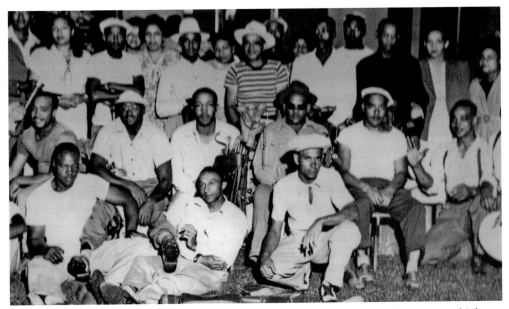

EAST DENVER GOLF CLUB. The East Denver Golf Club was formed in 1942 by a group of African Americans from east Denver who played out of City Park Golf Course. Not allowed to join the Colorado Golf Association or to play in CGA events, the East Denver Golf Club became a member of the Central States Golf Association, a group of 8 to 10 African American golf clubs from the Midwest states. This club photograph was taken in 1945. (Tom Woodard.)

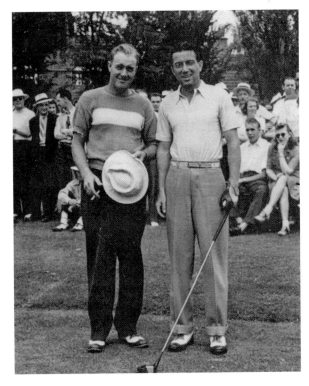

CLAUDE WRIGHT AND JOHN KRAFT, 1944 COLORADO STATE CHAMPIONSHIP. Although activities slowed down for golf courses during World War II, players not in the service still had the opportunity to play in state events. Accomplished players such as Claude Wright (left) and John Kraft, shown here at the 1944 Colorado State Championship, which Wright won, proved that the game was not only for the elite anymore. Wright was a plasterer by trade, and Kraft was a schoolteacher who supplemented his income by gambling on golf by day and gin rummy by night. (Dan Hogan.)

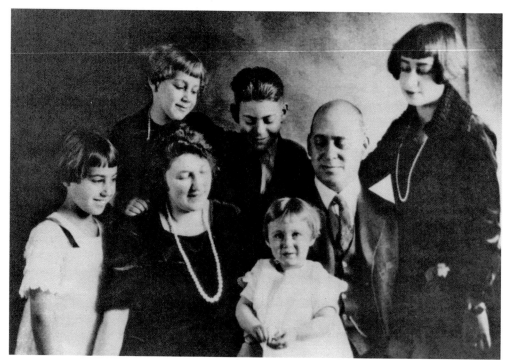

DOROTHY HEITLER. Dorothy Heitler, daughter of Samsonite founder Jesse Shwayder, is shown here on the top left at age 9 with her family. Heitler was a force in women's amateur golf in Colorado from the mid-1940s through the 1950s, winning the Colorado Match Play Championship in 1949 and the Colorado Stroke Play Championship in 1953 and 1956. She also won the Denver City Championship in 1956 and was Women's Club champion at Green Gables six times. (CHS F-36, 114.)

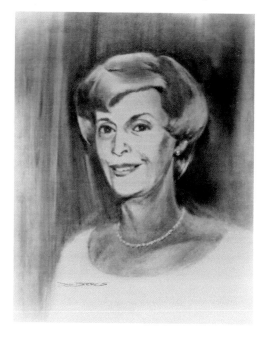

HELEN HYMAN COLORADO GOLF HALL OF FAME PORTRAIT. A contemporary of Dorothy Heitler, Helen Hyman claimed 24 Green Gables Club championships and won the Colorado Match Play in 1944 and 1948 and the Colorado Stroke Play in 1950. Hyman competed as a senior, winning the Colorado Senior Championship four years straight from 1964 to 1967 and again in 1974. (CGA.)

4

GOLF FOR ALL
1 9 4 6 – 1 9 6 7

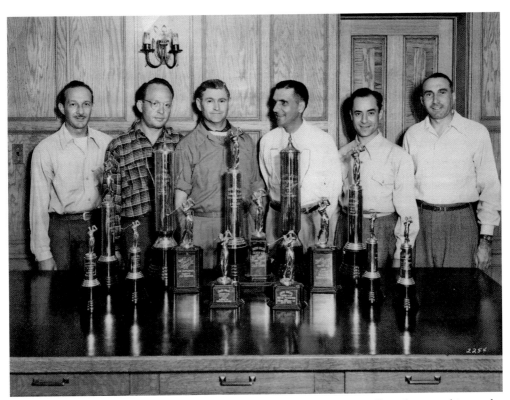

1946 GREEN GABLES CLUB CHAMPIONS. The tournament winners collect their trophies at the annual end-of-season banquet at Green Gables Country Club in 1946. That year marked the start up of many events postponed during the war years, including the major golf tournaments. A steady decline in golf participation was reversed in 1946, kicking off a postwar golf boom. (GGCC.)

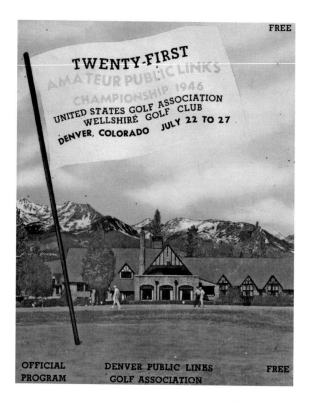

PROGRAM FROM 1946 PUBLIC LINKS AT WELLSHIRE. The 21st USGA Public Links tournament was held at Wellshire Golf Club in 1946. Robert "Smiley" Quick, a legendary amateur/gambler/hustler, won the tournament a week after winning the Park Hill Invitational. Wellshire established itself as a serious host for tournaments after this, including the 1959 USGA Public Links tournament and the Denver Open more than once. (CPGC.)

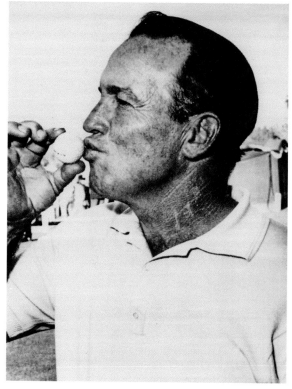

ROBERT "SMILEY" QUICK. Robert "Smiley" Quick was one of the best amateur golfers in the United States during the 1940s and 1950s. Quick preferred to have something riding on a match, the higher the stakes the better. Quick came to Denver to play in the 1946 Park Hill Invitational, which he won, and he was able to pocket a portion of the $100,000 Calcutta betting pool. A week later, he played in the 1946 USGA Public Links amateur tournament at Wellshire Golf Club, which he also won. (Rob Mohr.)

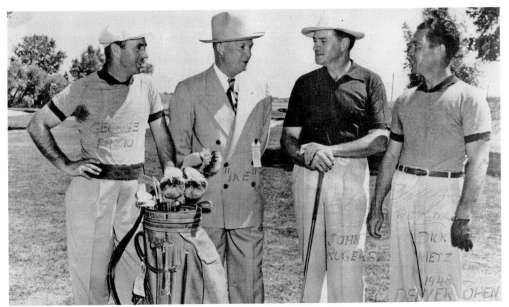

1948 DENVER OPEN. The Denver Open was a PGA Tour event. Lou Worsham, a solid pro who was having the best year of his career, won the 1947 event at Cherry Hills. In 1948 at Wellshire, Ben Hogan, thinking his score wouldn't hold up, left after his final round and was not present to receive his trophy or the winner's check. Pictured from left to right are touring pro George Fazio, retired Gen. Dwight Eisenhower, Park Hill Golf Club professional John Rogers, and touring pro Dick Metz. (Dan Hogan.)

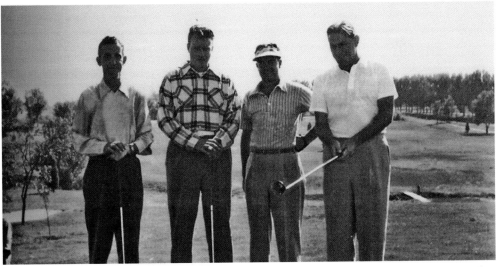

CREAM OF THE CROP, 1948. After World War II, several local outstanding players emerged as Denver's population boomed and nearly everyone took a sudden interest in golf. Lakewood's team was particularly well known. Shown here in 1948 are, from left to right, Charles "Babe" Lind (the first Coloradan to play in the Masters), Don Bell, Lakewood's head professional Gene Root, and professional golfer Jim Ferrier. (John R. Gardner II.)

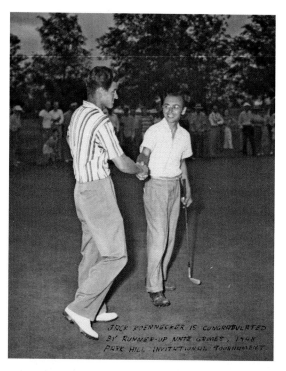

NATE GRIMES AND JACK KOENNECKER, PARK HILL INVITATIONAL, 1948. Nate Grimes (right) congratulates Jack Koennecker for his victory at the Park Hill Invitational of 1948. Koennecker was a strong amateur player in the 1940s. He would go on to a career as a club professional, landing at the Canyon Country Club in Palm Springs, California, in 1961, where he became a golfing confidante to Frank Sinatra and his Rat Pack. (Dan Hogan.)

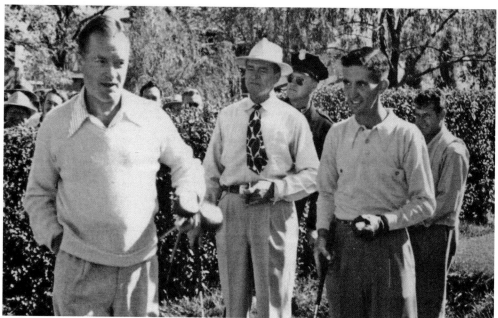

BOB HOPE AT PARK HILL GOLF CLUB. Bob Hope walks from green to tee with John Rogers (center) and Babe Lind (right) at Park Hill Golf Club in the late 1940s. Hope and his friend Bing Crosby played often in the Park Hill Invitational. Lind served as the men's golf coach at the University of Denver in the late 1940s and early 1950s before taking the position as director of golf for the city of Denver in 1955. (CGA.)

GOLF FOR ALL: 1946–1967

BABE LIND IN 1948. Babe Lind took up golf in 1932 at the age of 20, when Overland Park Golf Course opened. An established Colorado player, Lind became Denver's first director of golf in 1956 and, except for a four-year period, served in that role until 1987. Lind upgraded municipal courses by adding bunkers, expanding greens, building new tee boxes, and planting over 8,000 trees. Lind is shown at Park Hill Golf Club in 1948. (CPGC.)

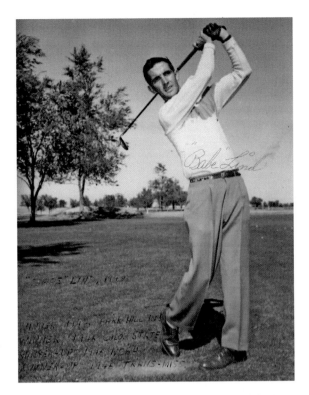

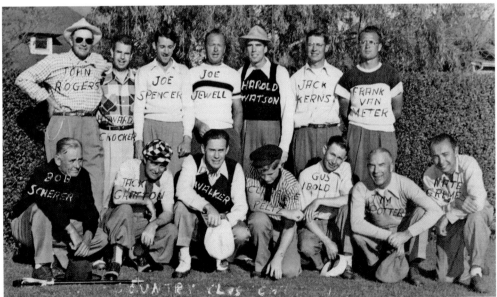

1949 PARK HILL TEAM. The 1949 Park Hill club team had some impressive members. Kneeling from left to right are Bob Shearer, owner of Park Hill Golf Club; Jack Gratton; Dan Walker; Clarence Peltz; Gus Bold; Jim Potter; and Nate Grimes. Standing from left to right are John Rogers, head professional at Park Hill; Howard Crocker; Joe Spencer; Joe Jewell; Harold Watson; Jack Kerns; and Frank Van Meter. Kerns and Grimes both won state championships. (Dan Hogan.)

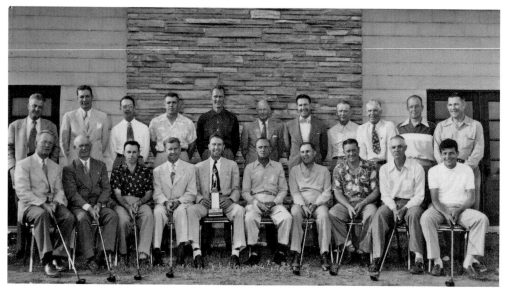

BOULDER COUNTRY CLUB FIFTH ANNUAL INVITATIONAL. The championship flight participants in the 1950 Boulder Country Club Invitational tournament pose in front of the clubhouse's distinctive flagstone chimney. Les Fowler is in the front row, seated to the right of the champion holding the trophy. In 1948, Boulder Municipal Sports Center purchased 2.6 acres of the golf course from the city of Boulder and built a new clubhouse that included a pro shop, bag storage, and a grill. (CBLLHBC.)

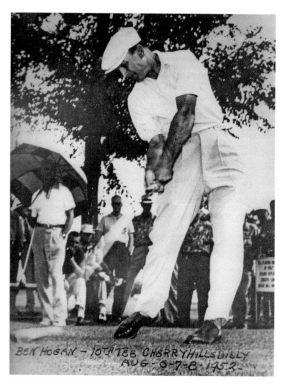

BEN HOGAN 1952 HILLSDILLY. Ben Hogan had many friends in the Denver area, and he made numerous visits to the city. Here, Hogan tees off in the Cherry Hills Country Club annual weeklong golf bash, the Cherry Hillsdilly, in 1952. Hogan's most memorable appearances in Denver were at the 1948 Denver Open, which he won, and the 1960 U.S. Open, where he tied for the lead before making a bogey on the 17th hole of the last round. (Dan Hogan.)

"Babe" Didrikson Zaharias and Rip Arnold at Cherry Hills, 1950s. "Babe" Didrikson Zaharias (left) was the best women's player in the world from the 1940s through 1956, when cancer struck her down. Rip Arnold (right) was the very popular professional at Cherry Hills Country Club from 1939 to 1962, when he died unexpectedly at age 47 of a heart attack. Zaharias and her husband, George (a native of Pueblo, Colorado), spent a lot of time in Colorado. (Dan Hogan, photograph by Doug Kirkland.)

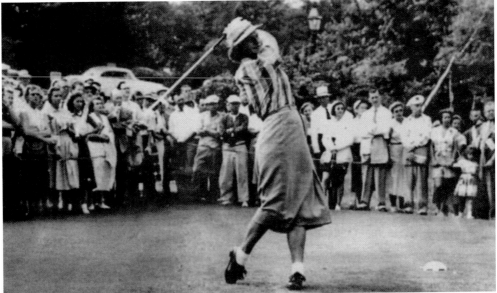

Babe Didrikson Zaharias at Lakewood Country Club. Babe Zaharias tees off at Lakewood Country Club in the late 1940s. Zaharias was perhaps the best woman athlete of the 20th century. She won national and international titles in basketball, as well as track and field, including two gold medals and a silver medal at the 1932 Olympics. She took up golf in 1935 and went on to win over 80 tournaments, including 10 major titles. She also qualified for several men's PGA tour events and made the cut twice, finishing as high as 42nd. (Dan Hogan.)

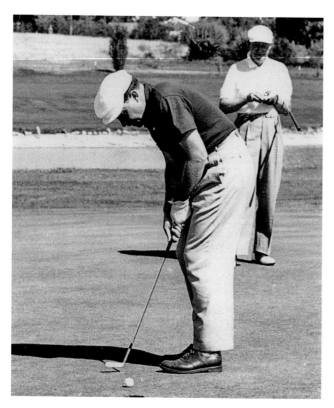

PRESIDENT EISENHOWER AND RICHARD NIXON AT CHERRY HILLS, 1953. Pres. Dwight Eisenhower and Vice Pres. Richard Nixon putt at Cherry Hills Country Club in 1953. Eisenhower was more than an avid golfer, playing over 800 rounds during his two terms as president. Eisenhower was reported to be around a 12 handicap, while Nixon did not particularly enjoy the game. The pressure of playing golf with the boss could not get much higher than it was for Nixon. (Rob Mohr.)

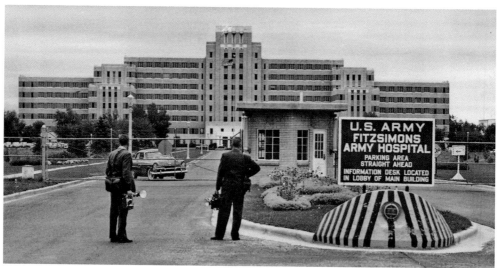

PAPARAZZI WAIT FOR IKE, FITZSIMONS HOSPITAL, SEPTEMBER 1955. In September 1955, then-president Dwight Eisenhower suffered a heart attack while visiting his in-laws in Denver. Eisenhower was playing 27 holes at Cherry Hills Country Club when he began to experience pain. The following morning, his wife and doctor admitted him to Fitzsimons for treatment. Over the next seven weeks, Eisenhower was on bed rest and in an oxygen tent, while paparazzi waited outside for news. (Rob Mohr.)

GOLF FOR ALL: 1946–1967

EAST DENVER GOLF CLUB PROGRAM, 1954. The Central States Golf Association held its annual weeklong tournament in Denver at Willis Case Golf Course in 1954. The CSGA was comprised of several African American golf clubs throughout the Midwest. Its tournament was hosted by a member club and drew several hundred players with a flighted tournament for men, a women's tournament, and a youth tournament. Joe Louis, the ex–heavyweight boxing champion, played many times in the annual event. (Tom Woodard.)

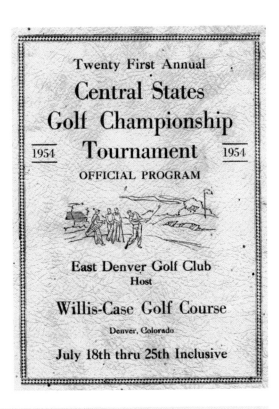

BEST WISHES TO EAST DENVER G. C. FROM PARK HILL G. C. An ad from the 1954 Central States Golf Association Championship program offers best wishes from Park Hill Country Club (also known as Park Hill Golf Club) and owner Bob Shearer. Park Hill Golf Club had a policy barring African Americans from playing at their club. (Tom Woodard.)

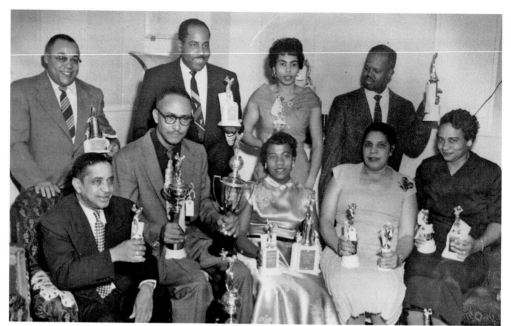

EAST DENVER GOLF CLUB AWARDS CEREMONY, 1954. Seated from left to right in this photograph are Leroy Hill, Lorenzo "Gip" Traylor, Delores Clark, Myrene Bryant, and Ernestine Waugh. Standing from left to right are Jay Taylor, Robert Whitlock, Mabel Sands, and Robert "Coochie" Marks. The East Denver Golf Club was active from 1942 through the mid-1970s and included many players with handicaps close to or below scratch. (Tom Woodard.)

ROBERT "COOCHIE" MARKS. Robert "Coochie" Marks, shown here in 1952, won the Central States Golf Association title in 1948 and repeated several times in the 1950s. He also won multiple East Denver Golf Club Championships. Marks's golf career came to a tragic end when he was in an automobile accident in the early 1960s and lost an arm. (Tom Woodard.)

COLORADO UNIVERSITY GOLF TEAM, 1953–1954. The 1953–1954 University of Colorado golf team, coached by 29-year-old Les Fowler and led by players Keith Alexander and George Hoos, powered their way to the Big 7 conference championship. In 1955, they repeated, tying for the conference championship with Oklahoma. From left to right are (sitting) Bob Webb, Keith Alexander, Jim Day, and George Hoos; (standing) coach Les Fowler, unidentified, Sam Beeler, unidentified, and John Kettman. (University of Colorado Athletic Department.)

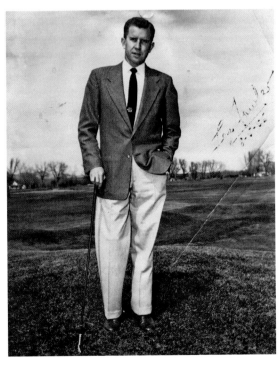

LESLIE FOWLER IN 1955. Leslie Fowler is the only golfer to have won the Colorado Match Play Tournament, the Colorado Stroke Play Tournament (three times), the Colorado Senior Stroke Play, and the Colorado Senior Match Play Tournament. He also served as a Boulder City councilman from 1956 to 1962, a state representative in 1967 and 1968, and a state senator from 1969 to 1988. After retiring from public office, Fowler served 13 years on the board of directors at University Hospital. (CBLLHBC.)

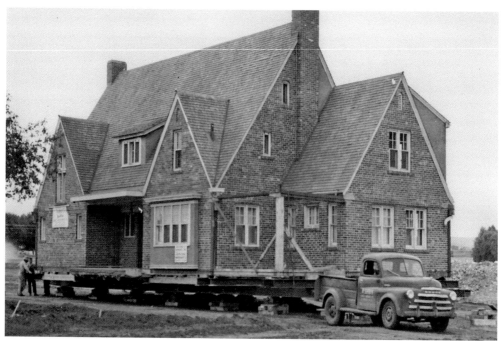

MOUNTAIN VIEW CLUBHOUSE MOVES, 1955. The Murchison brothers of Texas purchased the Mountain View Golf Course property in 1955 and began planning a commercial development for the site at Twenty-eighth Street and Arapahoe Avenue in Boulder. Bernice Geer purchased the two-story brick clubhouse building in 1955 and had it moved from the golf course to its new location at 2825 Marine Street. Geer remodeled the building and opened a restaurant. (CBLLHBC.)

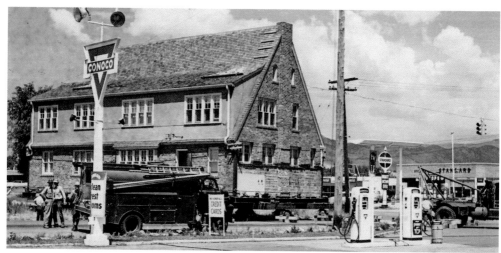

MOUNTAIN VIEW CLUBHOUSE AT TWENTY-EIGHTH STREET. The Mountain View Clubhouse, in the process of being relocated, waits for overhead wires to be moved before proceeding across Twenty-eighth Street in Boulder. The Murchison brothers kept the Mountain View course open until 1964, when construction began on the Arapahoe Shopping Center, Safeway, and the Harvest House Hotel, now the Millenium Harvest House Hotel. (CBLLHBC.)

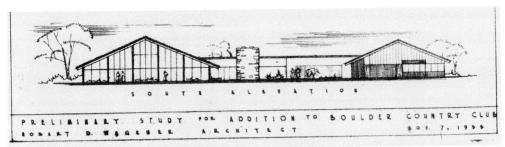

ARCHITECTURAL ELEVATION PLAN, NEW BOULDER COUNTRY CLUB CLUBHOUSE. This architectural rendering of the clubhouse additions at Boulder Country Club is from 1955. About all that remained of the original clubhouse was the flagstone chimney. The club added locker rooms, a full-service kitchen and formal dining room, several patios, tennis courts, a swimming pool, and a putting green. (CBLLHBC.)

VIVIAN DORSEY. Vivian Dorsey was a quiet powerhouse amateur who played at both City Park Golf Course and Wellshire Golf Course, winning club championships 16 times. She competed in national events such as the Trans-Mississippi and the Women's Western Amateur, and she had quite a successful career as a senior golfer in local and national tournaments as well. (CGA.)

Columbine Country Club

Surrounding the championship golf course, in the natural setting of beautiful Platte River Valley, Columbine Country Club offers the suburban homeseeker truly ideal country living. The new club house, championship golf course, swimming pool, and children's play area leave nothing to be desired for family recreation and entertainment.

Some 200 carefully planned homesites, each with an open view of the mountains, plateau area, and winding river gives one a feeling of wide open spaces as well as country club attractions.

Columbine is a new development with all new homeowners protected by an architectural commission to which all plans must be submitted. The Columbine Improvement Association is a further guarantee against deterioration of property investment. All utility installations are underground throughout the area.

The shops in Littleton are but five minutes away, and to downtown Denver a quick drive of only 22 minutes.

Home planning to include a golf course is the newest in planned residential living. Similar projects such as Thunderbird at Palm Springs, and Paradise Valley at Phoenix have quickly sold out.

These sites are a minimum of ½ acre and are priced from $5,250.00 to $8,750.00. Prices subject to change without notice.

VAN SCHAACK & CO.
AGENT
624 17th St. AComa 2-1661
CHERRY CREEK SHOPPING CENTER

COLUMBINE COUNTRY CLUB SALES BROCHURE, 1955–1956. In 1954, realizing that the growing population of Denver was creating a demand for another country club, a group of members from Cherry Hills began exploring the idea of building a new one. They located land southwest of Denver along the South Platt River, and in a unique business model, the country club and surrounding housing development formed an incorporated town. The course opened in 1955. This advertising piece was distributed through pro shops, at tournaments, and through targeted mailings. (Tom Woodard.)

COLUMBINE COUNTRY CLUB CLUBHOUSE. Designed by Francis Pillsbury, the one-story Columbine clubhouse reflects its founders' desire that Columbine Country Club be first-class and functional but not ostentatious. In 1959, the town of Columbine Valley was incorporated with the clubhouse, which also served as the town hall. (CCC.)

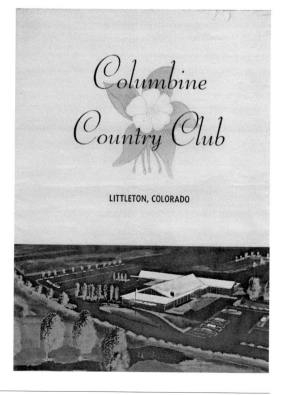

Columbine Country Club

LITTLETON, COLORADO

GOLF CART ADVERTISEMENT, 1957. This ad for a Sears Lectracar Diplomat golf cart ran in golf magazines in 1957. Sears also marketed golf shoes and golf clubs under the Sears name from 1957 through the mid-1960s before getting out of the golf business. (Rob Mohr.)

VALLEY COUNTRY CLUB GROUND-BREAKING, 1955. Founding members and their families break ground to start construction of the Valley Country Club course and clubhouse in the autumn of 1955. The course, designed by William Bell, opened in 1956. Valley Country Club was part of the wave of new country clubs built around Denver from the mid-1950s through the mid-1960s to meet the increasing demand for golf. (Valley Country Club.)

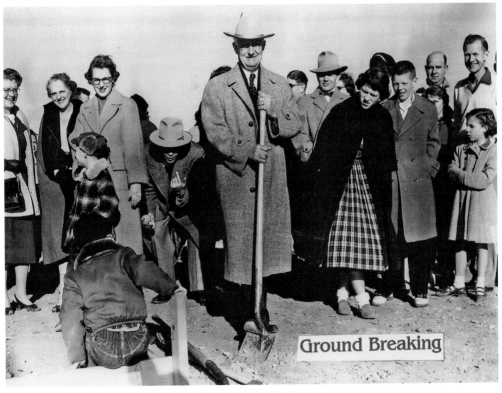

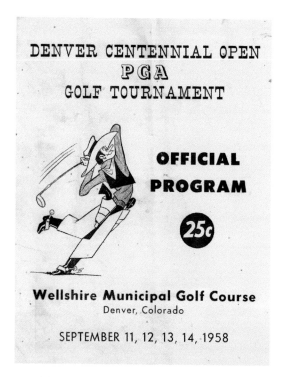

DENVER CENTENNIAL OPEN
PGA
GOLF TOURNAMENT

OFFICIAL
PROGRAM

25¢

Wellshire Municipal Golf Course
Denver, Colorado

SEPTEMBER 11, 12, 13, 14, 1958

PROGRAM, 1958 CENTENNIAL OPEN. The Denver Open was revived in 1958 and renamed the Denver Centennial Open in honor of Denver's centennial that year. Held at Wellshire Golf Club, the PGA Tour event was won by Tommy Jacobs. (CPGC.)

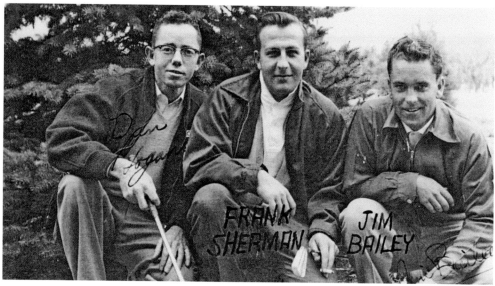

DAN HOGAN, FRANK SHERMAN, AND JIM BAILEY AT CITY PARK, 1958. Dan Hogan, Frank Sherman, and James Bailey take a break at City Park Golf Course in 1958. Hogan won the Denver Muni-links Championship three times, played in two British Amateurs, and was club champion 10 times at City Park. Sherman was head professional and Bailey was the assistant professional at City Park Golf Course. Bailey went on to a career as a head professional and wrote the 1983 manual *The Golf Professional at a Public Golf Course*. Sherman later held several head pro positions. (Dan Hogan.)

GOLF FOR ALL: 1946–1967

DALE DOUGLAS. Dale Douglas grew up in Fort Morgan, Colorado, and was a star on the University of Colorado golf team from 1956 through 1959. Douglas joined the PGA Tour in 1963 and won three times. After turning 50, Douglas bloomed on the Senior Tour, winning 11 times including a major, the 1986 Senior Open. Douglas swings a club in the late 1950s. (Rob Mohr.)

PINEHURST ADVERTISEMENT, 1958. This advertisement soliciting members for Pinehurst Country Club ran in the 1958 Denver Centennial Open program. The club opened for play in 1960 with 27 holes. In the decade following the opening of Columbine Country Club in 1955, several country clubs such as Valley, Meadow Hills, Pinehurst, Hiwan, and Rolling Hills Country Clubs opened. Only Meadow Hills in Aurora was not successful. (CPGC.)

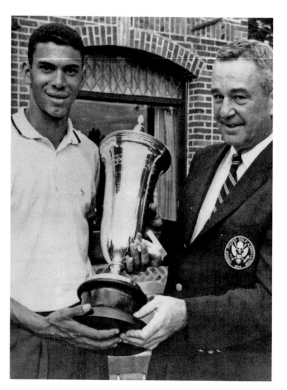

WILLIAM WRIGHT. William "Bill" Wright was the first African American to win a U.S. Golf Association title when he won the USGA Public Links Championship at Wellshire Golf Club in 1959. Wright was a 23-year-old student from Seattle, Washington, at the time of his victory. He is shown accepting the trophy from a USGA official. Wright went on to a career in golf as a club and teaching pro. (USGA.)

1960 U.S. OPEN AT CHERRY HILLS COUNTRY CLUB. The cover of *Golfing Magazine* shows the 18th green at Cherry Hills Country Club during the final round of the 1960 U.S. Open. Considered the greatest open in history, the tournament was the confluence of three generations of golf greats: Ben Hogan in his last competitive major, Arnold Palmer at the peak of his powers, and amateur Jack Nicklaus competing in his first major against professionals. The lead changed hands 12 times during the last 18 holes, with nine players having a realistic opportunity to win. (Rob Mohr.)

BEN HOGAN. Ben Hogan is shown in 1953. At age 47 at the 1960 U.S. Open, Hogan still had his ball striking skills but suffered from the yips with his putting. Having played 34 holes on Saturday, Hogan came to No. 17 knowing a birdie would give him the lead. Hogan cut it too close to the front flagstick on his third shot to the island green, spinning the ball back into the water. The resulting bogey took Hogan out of contention. (Rob Mohr.)

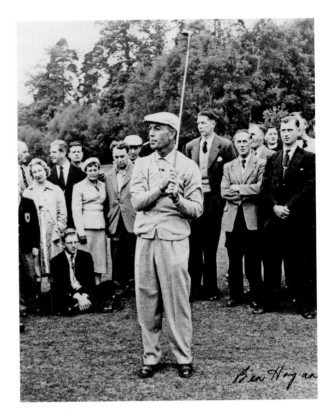

JACK NICKLAUS, 1965. In 1960, Jack Nicklaus was the reigning 1959 U.S. Amateur Champion. Only avid fans of amateur and college golf had heard of Nicklaus when he came to Denver to play in the U.S. Open. Yet Nicklaus finished second, only two strokes behind Arnold Palmer. This photograph of Nicklaus from 1965 was taken during his "Fat Jack" phase, shortly before his mid-1960s makeover into the "Golden Bear." (Rob Mohr.)

ARNOLD PALMER AT THE 72ND HOLE. Arnold Palmer was seven strokes back beginning the final round of the 1960 U.S. Open, with 12 players ahead of him. Palmer drove the first green, resulting in a birdie, and rattled off three more birdies in a row. Palmer already had earned the reputation as a go-for-broke aggressive player, and his charge at Cherry Hills electrified golf fans. Here, Palmer throws his visor after holing out the final putt for par on the 18th green. (USGA.)

Elect

JUDGE JAMES C. FLANIGAN

Democrat

DISTRICT JUDGE
(6-year term)

JUDGE JAMES FLANAGAN REELECTION CARD. Judge James Flanagan was a Denver municipal judge and founding member of the East Denver Golf Club. In 1961, Flanagan challenged the Colorado Golf Association's unwritten rule barring African Americans from participating in their sanctioned tournaments by registering for the Colorado State Amateur. When he arrived to sign in for the tournament, he was barred from playing, on grounds that he was not a member of a CGA-sanctioned club. The East Denver Golf Club had applied for membership, but had been denied. The resultant negative publicity and changing racial attitudes led the CGA to revise its rules and admit minority clubs in early 1962. Flanagan commented to a *Denver Post* reporter the day after being turned away, "I don't want to socialize with them, I just want to play golf." (Tom Woodard.)

FOUR FOR JUSTICE. Shown are Floyd Papin (right) and Jerome Biffle (below). Papin and Biffle, along with La Jean Clark and Lorenzo "Gip" Traylor, were members of the East Denver Golf Club, and in August 1961, they challenged the racial discrimination policy at Park Hill Golf Club by showing up at the club attempting to purchase greens fees. Refused permission to play, the four sued in district court. The burden of ongoing legal action, and the unstated threat from Denver to cancel Park Hill's lease, led the club to cease its discriminatory practices. (Right, Tom Woodard; below, Drake University.)

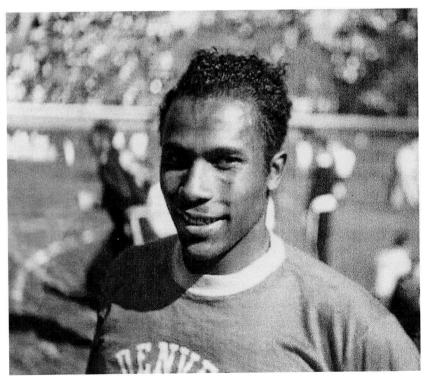

BOULDER COUNTRY CLUB CLUBHOUSE. By 1961, Boulder Country Club members were disenchanted with the terms of their lease with the City of Boulder. George and Everett Williams, Boulder real estate developers, built a residential community northeast of Boulder with a private country club as the centerpiece. The Williams brothers offered the course and clubhouse to Boulder Country Club as an enticement to move. The course was opened for play in 1963, with the spacious clubhouse opening in 1965. (Boulder Country Club.)

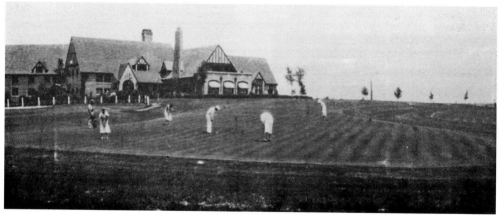

WELLSHIRE PUTTING COURSE. In 1962, tragedy struck Wellshire Golf Course when a fire broke out and destroyed the interior of the majestic Tudor-style clubhouse, built in 1927. The clubhouse was a reflection of the English images Wellshire brought to mind, as the exterior chimney and weather vanes were all imported from England. The interior was rebuilt in 1963 and again in 1977, when it was converted to an upscale event facility known as the Wellshire Inn. (Courtesy of City Park Golf Course.)

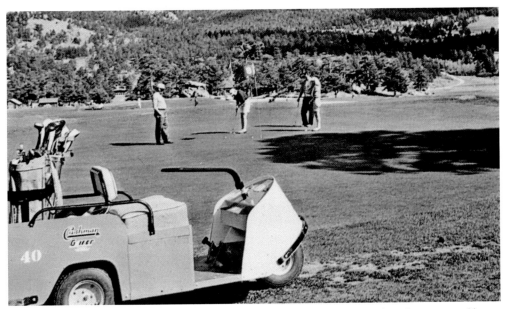

ESTES PARK GOLF COURSE, EARLY 1960S. Prominent in this photograph is the power golf cart. Power carts were introduced in the mid-1950s, and by the early 1960s, they had a tremendous effect on golf course operations. The primary casualties of the power cart evolution were caddy programs. Once a backdoor opening for minorities and the underprivileged to become involved in golf, the demise of caddy programs caused a drastic drop-off in minority participation in the sport. (Rob Mohr.)

DARST BUCHANAN. Darst Buchanan, an oilman from Oklahoma, owned the 14,000-acre Hiwan ranch, which stretched from Evergreen to Central City. Buchanan was a larger-than-life character whose adventurous lifestyle included big game hunting, arctic exploration, mountain climbing, and deep-sea fishing. He was also an excellent horseman. In 1962, Buchanan began building the Hiwan residential community with a golf course and clubhouse at the heart of the development. Buchanan hired well-known golf course architect Press Maxwell to design the mountain course. (JCHS and Hiwan Homestead Museum.)

DID YOU EVER DREAM OF A CHAMPIONSHIP GOLF COURSE IN YOUR BACKYARD?

Hiwan has it . . . and much more too!

■ Please accept our invitation to visit Hiwan . . . it's a dream come true. A magnificent 18 hole championship golf course in the tall pines and rolling hills above Denver. Designated one of Colorado's top courses by the U.S.G.A. And, when you come up to Hiwan, please introduce yourself to our Pro, Bob Hickman . . . he'll be delighted to meet you.
■ We said Hiwan is a dream come true . . . a beautiful clubhouse, fine food and drink, a large outdoor pool, and a complete pro shop.
■ Homesites are available that surround the golf course . . . wonderful family living with a superb school system for the children. And now, **Hiwan Hearths** is ready for your inspection: beautiful two-story apartments close to the clubhouse; an exciting and charming level of living . . . whether it is for year-round or week-end pleasure, or as income property.
■ Hiwan is exclusively different . . . yet a dream within the means of many discerning and appreciative people. Come to Hiwan soon . . . you won't want to leave!

Hiwan

EVERGREEN, COLORADO / PHONE 674-3366

For additional information please contact
HOGAN/STEVENSON REAL ESTATE
Denver Sales Office: 158 Fillmore/Phone 399-1770

DAVE HILL. Dave Hill made his home in Colorado after he turned professional in 1958. Hill Played the PGA Tour for 20 years, winning 13 times. Hill also served as head professional at Hiwan Country Club and was co-owner of Park Hill Golf Course from 1971 through 1975. Hill's candor made him a controversial figure his entire career. Seen here during the Pebble Beach Pro Am in 1972, he told a reporter, "Golf isn't fun anymore." (Rob Mohr.)

AD FOR HIWAN DEVELOPMENT. Darst Buchanan's vision of a challenging golf course with a rustic yet elegant clubhouse had been a reality for five years when this ad for Hiwan Country Club properties was produced in 1967. The course opened in 1962 and hosted the first Colorado Open a mere two years later. In the 1960s, 1970s, and 1980s, the tournament attracted many PGA players and nationally ranked amateurs. (Rob Mohr.)

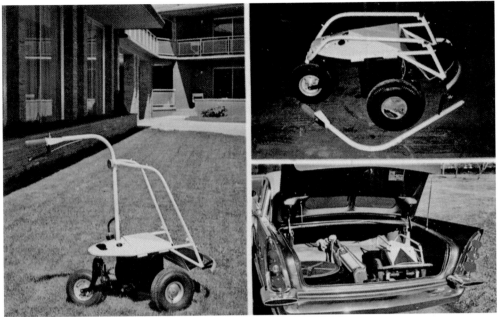

MARCUS MOTORS FOLDAWAY POWER CART. This advertising postcard for Marcus Motors of Denver's foldaway power cart is from the mid-1960s. Marcus Motors was a Packard and Studebaker automobile dealer in Denver and was looking for alternative markets after the demise of both makes. Battery-powered foldaway carts failed to find a market until the 1990s, with the advent of lightweight compact battery technology. (Rob Mohr.)

MILE HIGH GOLF CLUB, 1962. The Mile High Golf Club was a club for Asian Americans formed in the early 1960s. They played out of Willis Case Golf Course. Another Asian American club was the Cathay Post Golf Club, which played at several different courses in Denver during the 1960s. The Mile High Club members are shown at their annual banquet in 1962. (CPGC.)

JUAN "CHI CHI" RODRIGUEZ, 1963 DENVER OPEN. The Denver Open was played as a PGA Tour event intermittently between 1947 and 1963. In 1963, the winner, Chi Chi Rodriguez, who grew up in poverty in Puerto Rico, was making a name for himself on the PGA Tour with his excellent play and theatrics on the putting greens. Rodriguez is the only PGA Tour golfer to grace a rock band's album cover with his portrait on Devo's 1978 release, *Are We Not Men*. (Rob Mohr.)

JOAN BIRKLAND, c. 1965. Joan Birkland was a star in tennis as well as golf. In 1960, she won the Denver amateur tennis title, the Colorado state tennis title, and the Colorado Women's Golf Association Match Play golf title. Marcia Bailey, Birkland's chief golf rival, seemed to win the Colorado Women's Golf Association (CWGA) titles in the years that Birkland did not. (CGA.)

MARCIA BAILEY, CITY PARK PRACTICE RANGE, 1958. Marcia Bailey won the Denver Invitational in 1963 and 1967 and the CWGA Match Play in 1963, 1965, 1966, and 1967. She turned professional in 1968 and played on the LPGA tour for several years. She was married to fellow professional golfer Jim Bailey, and the Baileys started the Bailey Golf School and the Bailey Golf Tours and developed a golf curriculum for disabled golfers. They also developed and hosted a fund-raising tournament for the disabled. (Dan Hogan.)

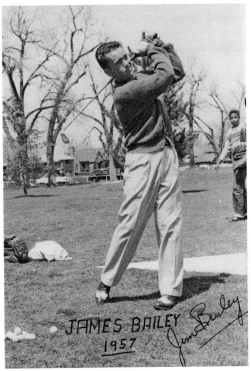

JIM BAILEY, 1957 AT CITY PARK GOLF COURSE. Jim Bailey started his professional career as an assistant pro at City Park in 1955. He was named head professional at Hyland Hills Golf Course in 1964. In 1962, Bailey and his wife, Marcia, built a four-hole course at Fort Logan Mental Health Center and developed a golf curriculum tailored for those with special needs. Bailey was the Colorado PGA Professional of the Year in 1964 and was awarded the National PGA Horton Smith Award in 1976. (Dan Hogan.)

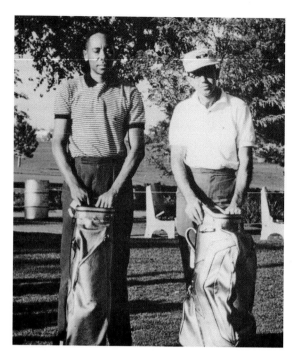

DAN HOGAN AND HERB BOLDEN, 1963. Dan Hogan (left) and Herb Bolden pose at Overland Golf Course in 1963. Bolden, a member of the East Denver Golf Club, and Hogan, a member of the City Park Men's Club, were club champions at their respective clubs multiple times and met in the final match of the 1965 Denver Muni-links Championship, which Bolden won. Hogan and Bolden played together multiple times in team events, including this tournament at Overland. (Dan Hogan.)

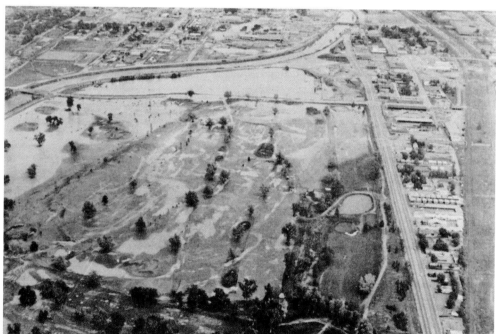

1965 FLOOD, OVERLAND GOLF COURSE. Overland Golf Course is shown underwater on June 17, 1965, the day after the South Platte River flooded. The river is to the left in the photograph. Sixteen greens were destroyed, and a layer of muck and debris covered the course. Babe Lind, director of golf for Denver, started the cleanup and rebuilding process the day after the flood and had the course ready for reopening in the spring of 1966. (Hotchkiss Printing.)

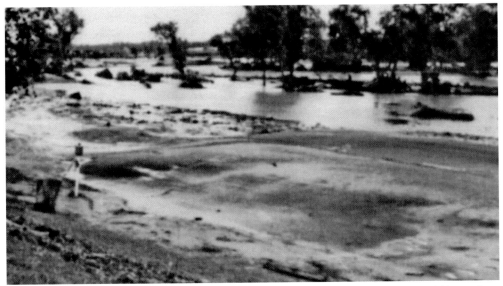

COLUMBINE 13TH TEE FLOODED. On June 16, 1965, a storm with tremendous rainfall in a short period of time, combined with saturated ground and swollen tributaries, created a slow-moving 15-foot swell of water that destroyed buildings, bridges, trees, and automobiles. The flood covered everything within a quarter-mile on either side of the river, including most of the Columbine Country Club. This is the 13th tee near the river the day after the flood. (CCC.)

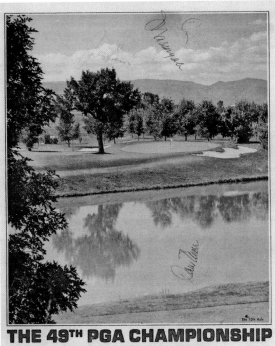

THE 49TH PGA CHAMPIONSHIP
JULY 20, 21, 22, 23, 1967
COLUMBINE COUNTRY CLUB ✦ DENVER-LITTLETON, COLORADO

1967 PGA PROGRAM. Columbine Country Club was originally slated for the 1966 PGA Championship, which was somewhat remarkable as the club was only opened in 1955. The flood of June 1965 destroyed the course, causing the PGA to trade tournament dates with Firestone Country Club (originally scheduled to host in 1967). By July 1967, Columbine was ready to host the tournament. (Rob Mohr.)

EVERETT AND LUCILLE COLLIER, EARLY 1960S. Everett Collier was the owner of Collier Electric and a founder of Columbine Country Club. Collier played the lead role in bringing the PGA Championship to Columbine and working with all involved to reschedule it following the flood of 1965. In this photograph, note the three-wheeled cart, a design that proved susceptible to rollover accidents. It was replaced by the four-wheeled cart design in the 1970s. (CCC.)

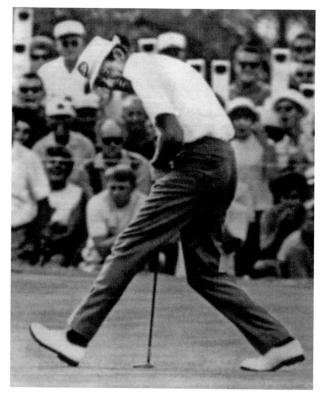

DON JANUARY PUTTING. Don January applies body language to get a putt to drop in on his way to victory at the 1967 PGA Championship at Columbine Country Club. He was tied at the end of regulation with Don Massengale; the players returned on Monday for an 18-hole play-off that January won, posting a 69 to Massengale's 71. (CCC.)

GOLF FOR ALL: 1946–1967

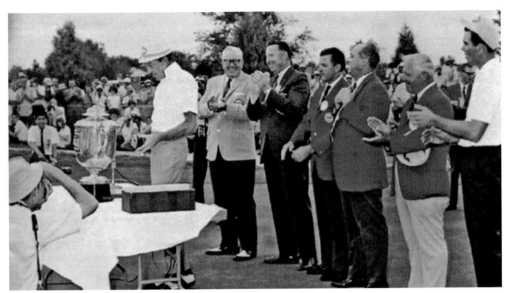

PGA Championship Trophy Presentation, 1967. Don January receives the trophy for winning the PGA Championship in 1967 at Columbine Country Club. January won 11 times on the PGA Tour, but the 1967 PGA was his only major. January was one of the first stars on the PGA Senior Tour as well. Everett Collier is wearing the light-colored sports jacket; standing to his left is Denver mayor Tom Currigan. (CCC.)

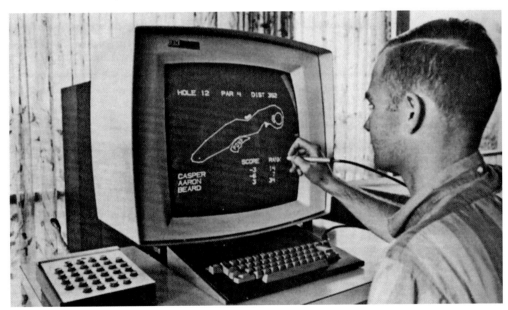

Early Computer Technology. The early telecast of golf on television consisted of one stationary camera located at the 18th green. By 1967, advancing technology had improved telecasts immensely. By the 1967 PGA Championship at Columbine, camera towers were located at every hole of the back nine, with computer graphics appearing on screen for the first time. In this 1967 ad from the PGA program, a technician demonstrates the techniques used at the time. (Rob Mohr.)

PRESS MAXWELL. Press Maxwell started golf course design with his father, Perry Maxwell, prior to World War II. During the war, Press Maxwell flew 81 combat missions over Europe. Upon Perry Maxwell's death in 1952, Press Maxwell took over the firm, relocating it to Morrison, Colorado. Maxwell designed or remodeled over 20 courses in Colorado, including Boulder, Hiwan, Rolling Hills, Pinehurst, Columbine, and Kissing Camels Country Clubs. He also designed major venues Southern Hills and Pecan Valley Country Club. (CGA.)

5

100 Years of Golf
1968–Present

HALE IRWIN. Hale Irwin, a Boulder High School graduate, was a two-sport athlete at the University of Colorado from 1966 to 1967. Irwin won the 1967 NCAA Championship in golf and went on to 20 victories, including three U.S. Opens, on the PGA Tour. On the PGA Senior Tour, Irwin won 45 titles, including two Senior Opens. He is a member of the World Golf Hall Of Fame. Fred Waring presents the NCAA Championship trophy to Irwin in 1967. (Rob Mohr.)

VALLEY COUNTRY CLUB 10TH HOLE, 1968 AND 2010. The top view of the 10th hole at Valley Country is from 1968, shortly after the pond was installed. The par-four hole plays 451 yards downhill, sweeping slightly to the right around the pond. The clubhouse is in the background on the hill. The modern view below, from 2010, shows mature trees that dictate a tee shot to the left side to open up the green. (Both, Valley Country Club.)

VIEW OF DOWNTOWN DENVER FROM CITY PARK GOLF COURSE, 1969. This postcard shows the stunning view of downtown Denver in 1969 from the City Park Golf Course. The course is located across Twenty-third Avenue from the Denver Zoo, so early-morning golfers hear a cacophony of sound from the animals as they wake up and are fed. Businessmen and tourists staying at downtown Denver hotels are a five-minute car ride from the course. (Rob Mohr.)

KATY FIORELLA. Club champion 22 times at Willis Case, Katy Fiorella began playing competitive golf in the late 1950s, finishing runner-up in the Denver Women's Invitational. She then won the 1959 CWGA Match Play Championship. After taking a break from competitive golf, Katy returned in the 1970s, finishing runner-up in the CWGA Match Play tournament several times. Her first individual senior title came in 1984, in the CWGA Senior Stroke Play Championship. (CGA.)

ARROWHEAD GOLF COURSE. As far back as the early 20th century, the City of Denver wanted to purchase land in what is now Roxborough State Park, with the idea of building a golf course there. Not until 1972 was this dream half-realized, as private developers, not the City of Denver, created Arrowhead Golf Course in the area. Arrowhead was conceived as a high-end course where players pay a daily fee to receive a country club–like experience. (Arrowhead Golf Course.)

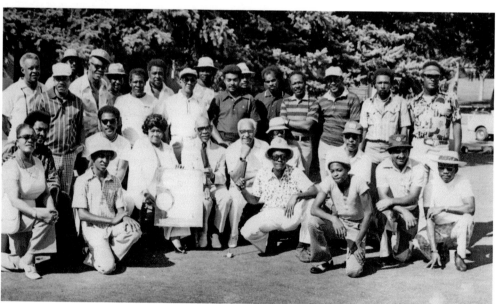

EAST DENVER GOLF CLUB, 1974. The East Denver Golf Club was nearing the end of its run in 1974. The gentleman seated near the center wearing a necktie is Maceo Rutherford, who started and ran a youth golf program in East Denver in the 1960s and 1970s. At left center, kneeling on one knee, is Daryl Knight, who went on to a career as a golf professional. Knight died of an aneurism at the young age of 37 in Orlando, Florida. (Tom Woodard.)

1974 LPGA National Jewish Hospital Open. The LPGA held an annual tournament in Denver from 1972 through 1987. In 1974, the LPGA National Jewish Hospital Open was held at Rolling Hills Country Club with Sandra Haynie prevailing. The cover of the program with Haynie's autograph shows a stylized painting of Rolling Hills. (Rob Mohr.)

Richard M. Phelps. Richard "Dick" Phelps designed over 400 golf courses in 14 states, with the majority being public courses in Colorado. Phelps's design philosophy was to put all the trouble where the golfer could see it, with the risk/reward to a shot apparent. Phelps designs included Perry Park Country Club, Raccoon Creek, Foothills Golf Course, the Meadows Golf Club, Saddle Rock, and Coal Creek Golf Course. (CGA.)

SIXTH ANNUAL

The National Jewish Hospital Open

Columbine Country Club
September 9-11, 1977

1977 LPGA NATIONAL JEWISH HOSPITAL OPEN. By 1977, the National Jewish Hospital Open was well established as an annual LPGA event in Denver. Hosted by Columbine Country Club, JoAnne Carner won the event. Columbine hosted the LPGA event in 1977 and under the Columbia Savings name in 1980, 1981, 1982, and 1983. (Rob Mohr.)

JOANNE CARNER, 1977 NATIONAL JEWISH HOSPITAL OPEN. Joanne Carner reacts to a putt at the 1977 National Jewish Hospital Open, which she won. Carner also won five U.S. Women's Amateurs. As a professional, Carner won 43 tournaments, including two majors, and earned the nickname "Big Momma." Carner was a long hitter, driving the ball 250 yards with a Persimmon driver and a wound balata-covered ball. (CCC.)

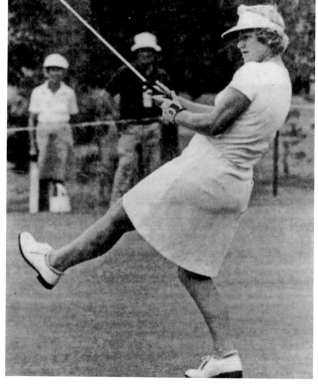

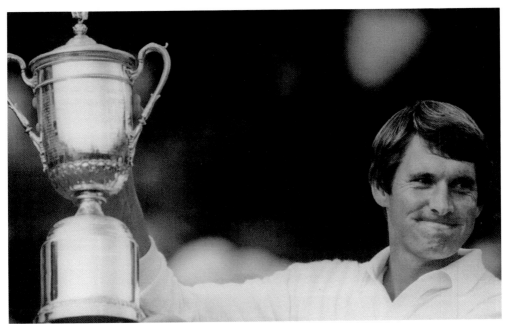

ANDY NORTH, 1978 U.S. OPEN AT CHERRY HILLS COUNTRY CLUB. Cherry Hills Country Club hosted the U.S. Open again in 1978. Andy North, an unheralded 28-year-old with one win on the PGA Tour, went into the final round with a one-stroke lead. Two shots in the rough, a third shot into a greenside bunker, and a great sand shot landing within 4 feet of the hole left North with every golfer's dream—a putt to win the U.S. Open. He went on to win another U.S. Open in 1985. (Rob Mohr.)

1980 COLUMBIA SAVINGS LPGA CLASSIC. Columbia Saving took over sponsorship of Denver's LPGA tournament in 1979. In 1980, the format was changed to 72 holes rather than 54, which proved to be beneficial to Beth Daniel, who earned first place, shooting 12-under on the Columbine Country Club course. The last year of the Columbia Savings LPGA tournament was 1987, ending a 14-year run of LPGA golf in Denver. (Rob Mohr.)

THE DENVER POST

CHAMPIONS OF GOLF

$2

Pinehurst Country Club, August 12-15, 1982

A NEW TRADITION

Arnold Palmer electrified the world of golf when he won the U.S. Open at Cherry Hills Country Club in 1960 (above). Palmer, now 52 (right), will be in Denver again, playing in the Denver Post Champions of Golf tournament at Pinehurst Aug. 12-15.

PGA TOUR

FOR THE BENEFIT OF CHILDREN'S HOSPITAL

DENVER POST CHAMPIONS OF GOLF, 1981. In the winter of 1981, the *Denver Post* published a column about an upstart professional golf tour. The Senior Tour was drawing large galleries with a core group of about 20 well-known golfers. Sponsors, led by the *Denver Post*, came forward. A tournament was born. Held at Pinehurst Country Club, the first *Denver Post* Champions of Golf tournament featured and was won by Arnold Palmer. (Rob Mohr.)

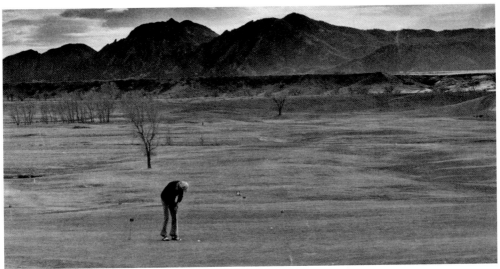

GEORGE CESSNA AT LAKE VALLEY GOLF CLUB, 1981. A man identified as George Cessna practices putting at Lake Valley Golf Club in November 1981. Located north of Boulder, the course is subject to high winds at times, as seen in the photograph. Beginning as a public course, the Lake Valley property changed hands several times over the years and is now a private club with a modest clubhouse but no swimming or tennis. (CBLLHBC.)

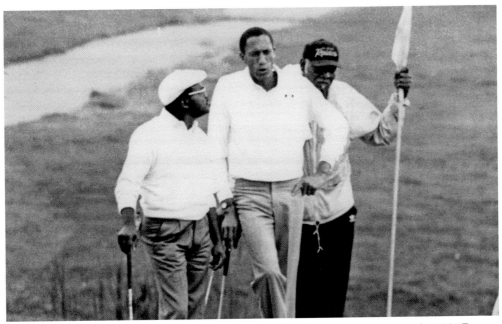

TOM WOODARD AT THE 1981 DENVER OPEN. Tom Woodard sizes up a shot at the 1981 Denver Open, a mini-tour event that lasted several years. Woodard went to the University of Colorado on an Eisenhower/Evans Caddy Scholarship. He walked on to the university golf team and became an honorable mention All-American. Woodard played the PGA Tour, the U.S. Open in 1988 and 1993, and the PGA Championship in 1991. (Tom Woodard.)

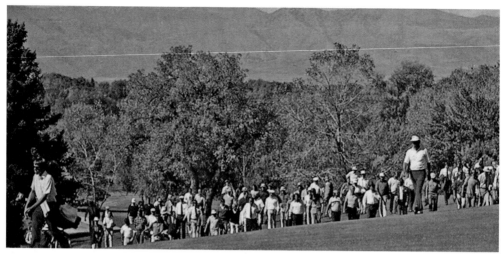

MID-AMATEUR AT CHERRY HILLS COUNTRY CLUB, 1983. Jay Sigel walks up a fairway at Cherry Hills Country Club during the 1983 USGA Mid-Amateur. Sigel won the British Amateur in 1979, the U.S. Amateur in 1982 and 1983, and the U.S. Mid-Amateur in 1983, 1985, and 1987. Sigel turned professional and joined the Champions Tour in 1994. Cherry Hills has hosted eight USGA Championships and two PGA Championships and will host the 2012 U.S. Amateur Championship. (CGA.)

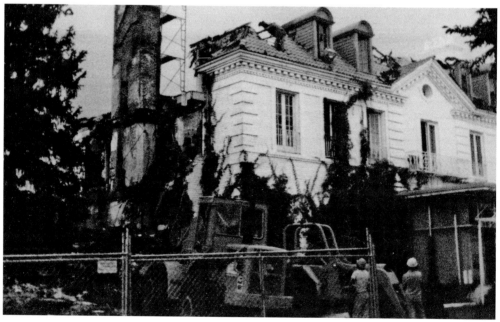

FIRE AT GREEN GABLES. Fire broke out due to an electrical malfunction in the Green Gables Clubhouse on November 20, 1983, gutting the interior. The process of rebuilding the clubhouse took some time, as the club debated whether to restore the clubhouse to the original design or tear it down completely and start anew. With the decision to restore the clubhouse to its original grandeur, construction was completed in the spring of 1987. (GGCC.)

THE ROCK HOLE AT EVERGREEN. To say the par-three "rock hole" at Evergreen Golf Course in Evergreen, Colorado, is a blind tee shot is a bit of an understatement. The photograph at right shows what the golfer sees from the tee box at the third hole. The hole plays 109 yards over the rock and hill to a green at the foot of the hill, as shown below from the crest of the hill. When golfers leave the green, they ring the bell on the pole to signal "all clear" to golfers in the tee box. When Babe Lind redesigned the Evergreen course in 1983 and 1984, he had to eliminate several dangerous tee box fairway crossovers, which resulted in having to squeeze in another hole somewhere. By necessity, but also befitting his sense of fun, Lind built this hole. (Photographs by Ed Cronin.)

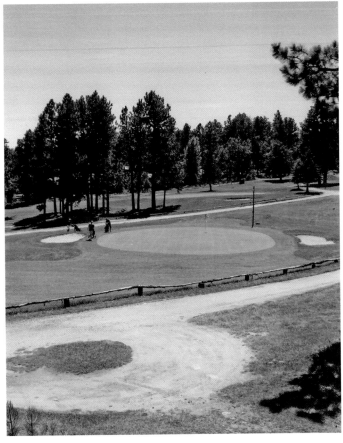

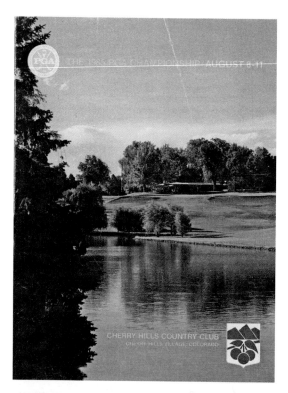

1985 PGA PROGRAM. A major golf tournament returned to Cherry Hills Country Club in 1985. This time, it was the PGA Championship, which Hubert Green won with a score of 10 under par. The cover of the program shows the view of the 18th green from the lake. (Rob Mohr.)

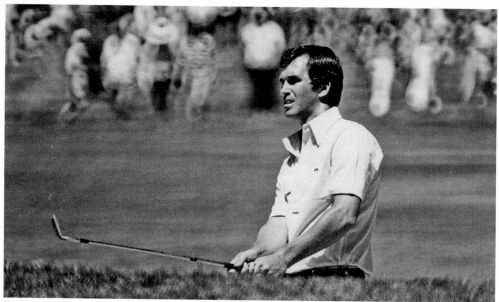

HUBERT GREEN. Hubert Green won his second major golf tournament at Cherry Hills Country Club in 1985. Green finished with 19 PGA tour wins, including two majors, before he moved to the Senior Tour in 1997. Diagnosed with throat cancer in 2003, Green has played a limited schedule as a senior. In this photograph, Green plays a practice round at Cherry Hills prior to the 1978 U.S. Open. (Rob Mohr.)

JACK VICKERS. Jack Vickers, a Denver oilman and avid golfer, built Castle Pines Golf Club in 1981 in Castle Rock, Colorado. Designed by Jack Nicklaus, the course is a long 7,695 yards with dramatic elevation changes and beautiful views of the Front Range. Almost immediately after the course opened, Vickers started lobbying to land a PGA Tour event. His efforts were rewarded when the PGA Tour gave Castle Pines a tournament in August 1986. (CGA.)

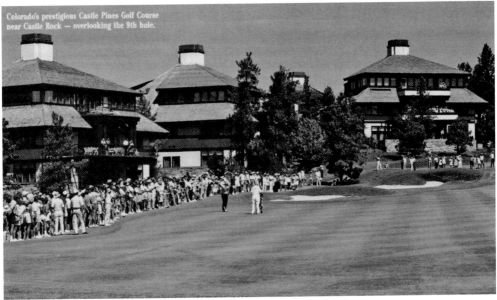

THE INTERNATIONAL, CASTLE PINES GOLF CLUB, 1986. Jack Vickers, wishing to separate his tournament from the rest, used a modified Stableford scoring system in which points are awarded for birdies and better and subtracted for bogeys or worse. The scoring system lead to some exciting finishes, and the tournament became a popular stop on tour, drawing strong fields. The tournament was played for 21 years, with Dean Wilson winning the last International played in 2006. (CGA.)

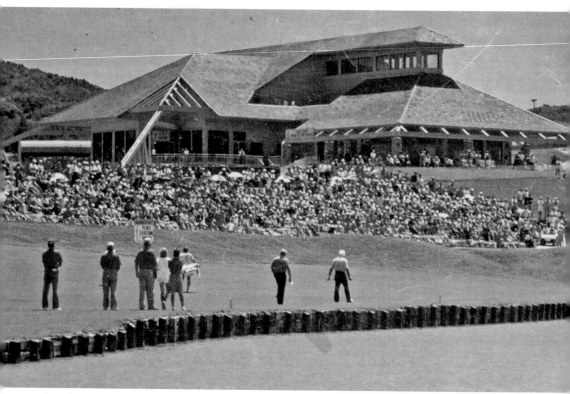

THE LAST DENVER POST CHAMPIONS OF GOLF TOURNAMENT, 1987. The *Denver Post* Champions of Golf tournament ran from 1982 through 1987. Held at Plum Creek Golf Club in Castle Rock, the last regular Senior Tour event in the Denver area was won by Bruce Crampton. Plum Creek Golf Club opened and operated as a private club, went semiprivate from the 1990s into the 2000s, and has returned to operation as a private club. (CGA.)

KEN GREEN. Struggling pro Ken Green won the first International held at Castle Pines in 1986 and went on to win four more times in the mid- to late 1980s. In June 2009, while having success on the Senior Tour, Green was driving his RV when a tire blew, sending the vehicle down an embankment into a tree. His brother, his girlfriend, and his dog were all killed in the tragic accident, and Green lost his right leg below the knee. Despite the loss of the limb, Green is attempting to come back and play competitively on the Senior Tour. (Rob Mohr.)

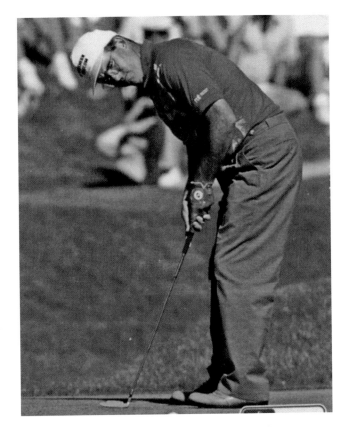

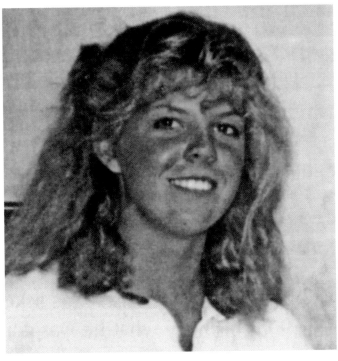

JILL MCGILL, 1988. Jill McGill is seen here at 16 years old after winning the Colorado Golf Association Match Play Championship in 1988. Girls' golf was not sanctioned by the Colorado High School Activities Association until 1990, so McGill played on the Cherry Creek High School junior varsity boys' team. She is one the few players to have won both the Women's U.S. Amateur and the Women's Public Links. McGill has played on the LPGA Tour since 1996. (CGA.)

STEVE JONES. Steve Jones spent his formative years in Yuma, Colorado, playing golf on sand greens. At the University of Colorado, Jones was All–Big Eight for four years and was named second team All-American. After winning several amateur and then professional tournaments throughout the 1980s, Jones won the U.S. Open at Oakmont in 1996. In this photograph, Jones is shown at his Colorado Golf Hall of Fame induction. (CGA.)

KEVIN STADLER. Kevin Stadler, son of PGA and Champions Tour player Craig Stadler, won the Colorado State High School 4A Championship in 1997. Stadler went on to a second-team All-American career at the University of Southern California and won the Colorado Match Play Championship in 1999 and 2002. Stadler currently plays on the European and PGA Tours. Above, Stadler (right) holds the winning trophy at the 2002 Colorado Match Play as runner-up Anthony Giarratano looks on. (CGA.)

PHIL MICKELSON. Phil Mickelson dominated college golf, winning two straight NCAA Championships when he arrived at Cherry Hills Country Club in 1990 to play in the U.S. Amateur. Mickelson became the first left-handed player to win a USGA Championship. As an amateur without any endorsement contracts, Mickelson preferred to play without wearing a hat or a glove, as this photograph from 1991 proves. (Rob Mohr.)

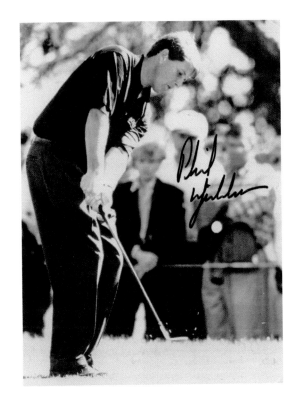

JUAN "CHI CHI" RODRIGUEZ, FIRST TEE. Chi Chi Rodriguez hosted a First Tee Clinic at City Park Golf Course in 2003. Denver Golf started a junior golf program in 2001, aligned with the First Tee program. They provide afterschool and summer programs in golf and life skills. The First Tee program has three short practice courses located at Willis Case, Wellshire, and City Park Golf Courses. (First Tee of Denver.)

2005 WOMEN'S OPEN. In an exciting dramatic finish, Birdie Kim holed out a greenside bunker shot for birdie on the 72nd hole of the 2005 U.S. Women's Open at Cherry Hills Country Club to break out of a tie with amateur Morgan Pressel. It was Kim's first U.S. Open and her first victory on tour. A smiling Kim holds the trophy. (Rob Mohr.)

TOM LEHMAN. Tom Lehman, a veteran PGA and Champions Tour player with five PGA Tour wins, checks his yardage book during a round at the International tournament at Castle Pines in the early 2000s. Lehman would win the 2010 Senior PGA Championship at the Colorado Golf Club in Parker, Colorado, in an exceptionally dramatic finish, defeating Fred Couples and David Frost in a sudden death play-off. (CGA.)

OLD AND NEW CLUBHOUSES, WILLIS CASE. The old Willis Case clubhouse, dating to 1929 (on the left), sits in contrast to the nearly finished new clubhouse on the right in January 2010. The old clubhouse was demolished in March 2010. (Photograph by Ed Cronin.)

ABOUT THE
ORGANIZATION

M.A. McLaughlin
*1915 CGA Match Play
Champion*

Gunner Wiebe
*2010 CGA Match Play
Champion*

Keeping the game you love the game you love.

Since 1915, the Colorado Golf Association has existed solely to preserve, improve and share all this great game has to offer with everyone in the state. To learn more about the CGA and how our 45,000 members are helping us to accomplish this, please visit

www.COgolf.org.

BIBLIOGRAPHY

Bonniwell, Charles C., and David Fridtjof Halaas. *The History of the Denver Country Club, 1887–2006*. Denver: Ocean View Books, 2004.

Gibson, Barbara. *The City Club of Denver, 1922–1997*. Denver: City Club of Denver, 1999.

Labbance, Bob, and Brian Siplo. *The Vardon Invasion: Harry's Triumphant 1900 American Tour*. Ann Arbor, MI: Sports Media Group, 2008.

Meister, George E. *Trajectory of a Tragedy: Denver Area Flood, June 16th–17th, 1965*. Denver: Hotchkiss, 1965.

Norman, Cathleen M. *Lakewood Country Club: A Colorado Classic 100 Years in the Making*. Virginia Beach: Donning Company, 2008.

Snow, Shawn M. *Denver's City Park and Whittier Neighborhoods*. Charleston, SC: Arcadia Publishing, 2009.

Vallier, Myron. *Historic Photos of Denver*. Nashville: Turner Publishing Company, 2007.

Vaughan, Roger. *Golf, The Woman's Game*. New York: Stewart, Tabori and Chang, 2000.

DISCOVER THOUSANDS OF LOCAL HISTORY BOOKS FEATURING MILLIONS OF VINTAGE IMAGES

Arcadia Publishing, the leading local history publisher in the United States, is committed to making history accessible and meaningful through publishing books that celebrate and preserve the heritage of America's people and places.

Find more books like this at
www.arcadiapublishing.com

Search for your hometown history, your old stomping grounds, and even your favorite sports team.

Consistent with our mission to preserve history on a local level, this book was printed in South Carolina on American-made paper and manufactured entirely in the United States. Products carrying the accredited Forest Stewardship Council (FSC) label are printed on 100 percent FSC-certified paper.

MADE IN THE
USA